MANGA
The Mega Guide

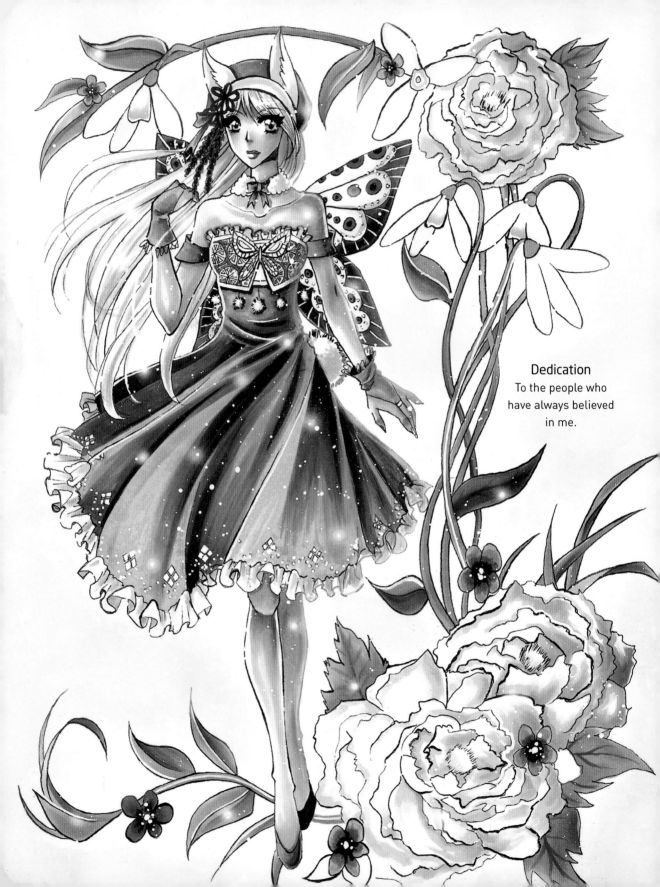

Dedication
To the people who
have always believed
in me.

MANGA
The Mega Guide

SAMANTHA GOREL

Search Press

First published in 2016

Search Press Limited
Wellwood, North Farm Road,
Tunbridge Wells, Kent TN2 3DR

ISBN: 978-1-78221-076-4

Suppliers
If you have difficulty in obtaining any of the materials and
equipment mentioned in this book, then please visit the Search
Press website for details of suppliers: www.searchpress.com

You are invited to the author's website here:
samanthagorel.com

Printed in China

CONTENTS

Introduction

Ten years ago I was in your place – reading the introduction of my first art tutorial book. Now I am writing my own. I started drawing manga in my first year of middle school and never stopped. In high school I drew in all my classes and still draw every day in college. I am not an art major; I do not attend a fancy art school. Everything I have learned is self-taught through tutorial books like this one and the internet. I want this book to show you exactly how I did this, by starting with the fundamentals of how to draw and moving on to show you the real details of how to draw past the basics when you are ready.

I have read through too many books that teach the theories, but not how to apply them. This book will teach you what the pros really do. In this book I will not be teaching you the most 'correct' way of drawing, but will instead show you how I actually draw. I will show you step by step what I am actually doing in an image – not just the theories, but how to apply them. I cannot promise to make you a professional overnight, but I can show you what I really do on a daily basis in my job.

I want you to become better than I am. I want you to learn everything you can from me and surpass me. I will teach you all I know, and how to draw and colour. If you draw every day and don't stop, you can be a professional manga artist too. One day, you won't be reading my book; I will be reading yours.

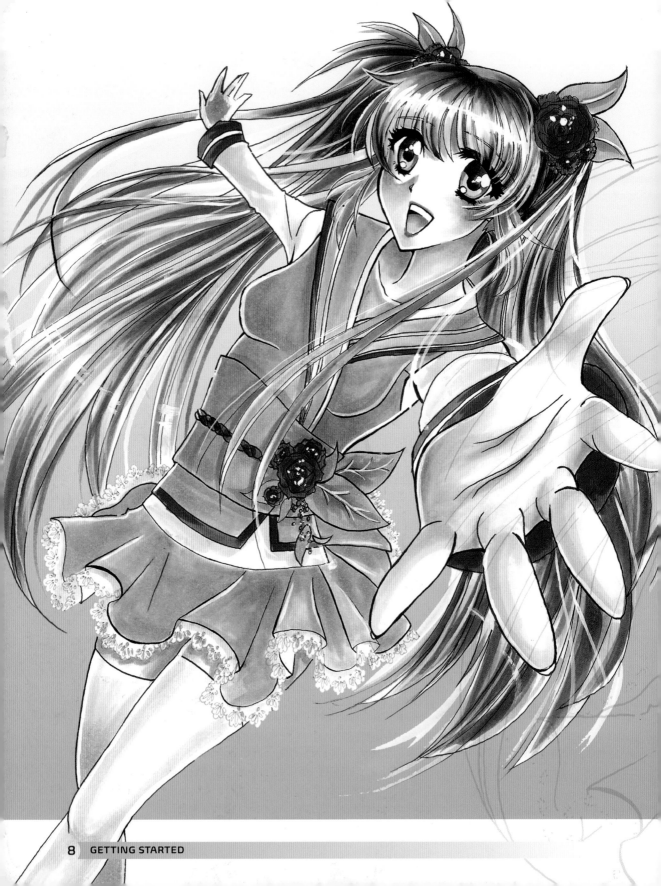

GETTING STARTED

Drawing is by far the most important part of illustration. It forms the basis of the artwork and without a solid understanding of drawing and motion, your finished piece will fall short. If you do not learn the basics and master them, your colouring and composition will not make up for the lack of drawing skill. Getting better at drawing takes a long time. Fill a dozen sketchbooks and you will be halfway there. Learn the basics and then practise them over and over again. Study the techniques used by others and make them your own.

 I will lead you through the basics into more advanced steps in this book, but after that you must practise every day and not stop. If you draw every day you will improve. Practise is the most important thing to do if you want to get better.

Learning how to draw

The learning process is a slow one and it may be frustrating for you if you do not see immediate improvement. Understand that improvement takes time and don't give up!

Copy, adjust, master

The three stages of blocks below show the fundamental process behind every drawing – copy the original as closely as you can, then study and adjust it to fix any errors or add any new touches you want, then develop it into a full drawing.

Compare your art with your previous work, not the works of others, and you will feel much better about your improvement. Never stop drawing and you will improve. Experience is the only way to learn and this takes time. Reference material can help you, and understanding what you are drawing will help you to master the process.

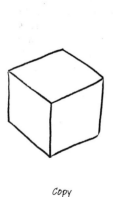

Copy

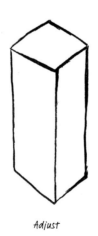

Adjust

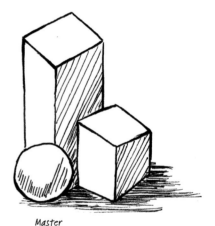

Master

The manga style

There are lots of differences between how we draw people in manga art and how we draw them in the realistic, or classical, style of art. These differences can be subtle, but they add up to creating the distinctive manga look.

Throughout the book, I will teach you what to look for, and how to draw your figures in the manga style. In order to do this, it's important to know a few basic facts about proportion.

Proportion

Proportions are the relative sizes of two things. A child has a proportionally larger head compared with its body than an adult, for example, even though their heads might be similar in actual size.

Manga plays around a lot with realistic proportions in order to create different visual effects – large eyes and small noses are appealing and cute, for example. That means you need to be aware of realistic proportions to master this more stylised effect – and this comes back to the three stages of copying what you see, adjusting it to change the proportions and mastering the style.

It may sound complicated, but don't worry. We will look at proportion together through the book, and see the effects it creates.

TOP TIP !

Manga proportions are broadly the same as realistic proportions. Although certain features are exaggerated, the skull of a manga character is essentially the same as a real person's.

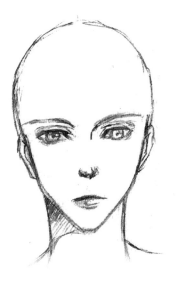 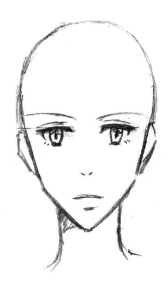

Realistic and manga proportions

Eyes in realistic proportions (above left) have the width of one eye between them. In manga art (above right), the proportions are typically closer to three-quarters of the width of one eye. Similarly, the other features may be slightly smaller than in real life, but they still sit in the same place as on real people.

FACES, EXPRESSION AND HAIR

Our eyes are immediately drawn to the face of a character first. It is therefore the most important part of any manga-style figure, and it is where we begin. Once you master the face, you will be ready to move on to the rest of the body.

If the face is not well drawn it will ruin the rest of the image. If there is no expression or the hair does not flow properly, the finished figure will not be believable. Take care in your drawing of the face and head and focus your effort on this important part of your picture.

The female face

The picture on the right-hand page shows the basic structure of a manga-style female face. Note that the basic shape of the head is the same as in a realistic drawing – the differences comes in the relative sizes of the features. Look carefully at the face and you will see where the differences between a realistic and manga-style face lie. I have added some notes to draw attention to important points of style.

Manga facial proportions

In terms of the female face, we can say that manga-style eyes are proportionally larger than real eyes. This means that they take up a bit more space on the face than in realistic artwork and extend further down the cheek. However, this just pulls the bottom eyelashes down further than they would sit in a realistic drawing, it does not change the eyes' basic structure.

Similarly, manga-style noses tend to be proportionally smaller than real noses, but they still sit in roughly the same position on the head.

As you draw, keep in mind that the placement of the features remains similar to a realistic portrait; the features are simply exaggerated by being made smaller or larger than they really are.

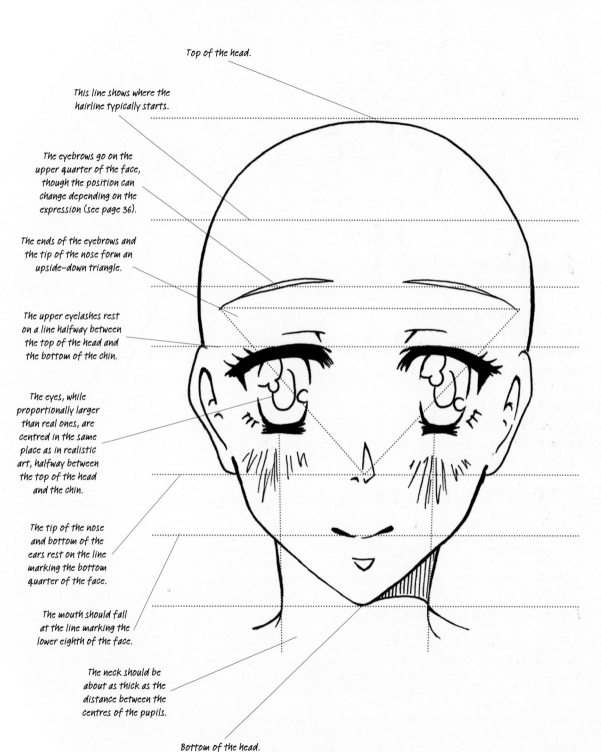

Top of the head.

This line shows where the hairline typically starts.

The eyebrows go on the upper quarter of the face, though the position can change depending on the expression (see page 36).

The ends of the eyebrows and the tip of the nose form an upside-down triangle.

The upper eyelashes rest on a line halfway between the top of the head and the bottom of the chin.

The eyes, while proportionally larger than real ones, are centred in the same place as in realistic art, halfway between the top of the head and the chin.

The tip of the nose and bottom of the ears rest on the line marking the bottom quarter of the face.

The mouth should fall at the line marking the lower eighth of the face.

The neck should be about as thick as the distance between the centres of the pupils.

Bottom of the head.

Drawing the female face from the front

The exercise on this page shows how to draw the female face from the front. Rather than trying to draw the jaw and skull first, we draw the eyes and build the rest of the head around these features. This approach makes it easier to get the proportions right, as it will force you to measure the distances when you draw so you know where to place the top of the head. Do not worry if it takes you a few tries to get the placement of everything right – even professional artists spend time redrawing features, and it is worth the effort to get a perfect result.

1 Start by drawing the upper eyelashes.

2 Add the lower eyelashes and iris, then the nose. Now you have the centre of the face and can build around it.

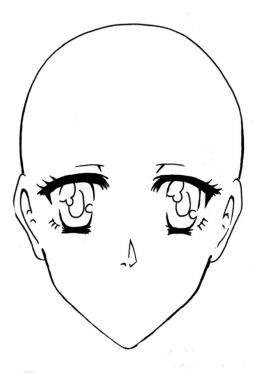

3 Referring to the proportions on page 13, add the jaw, skull and ears.

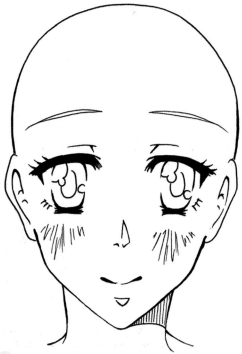

4 Add the neck and remaining facial details. If you do not get it right the first time, keep trying until it comes out correctly.

5 Use the information on pages 42–45 to draw the hair, then add colour to finish the picture. Note that the top of the head will always be covered by hair and will not be seen even in tight-fitting styles like the twin pigtails, shown here.

Drawing the female face from the side

The proportions of the face remain the same from the side as from the front, so as with the exercise earlier, you can use the features to help guide you. Whether you are looking at the face from the front or side, the bottom of the ear rests on the same line as the bottom of the nose, and the top of the ear rests on the eye line, for example.

There are, of course, some differences in how you draw the features that depend on the angle of the figure. For example, the part of the eye that is visible will change between front and profile views. However, understanding that the eye is essentially a sphere will help you shade and colour it properly, no matter the angle. There are many different styles of drawing a profile in manga style, and not all show a definite indent between the lips and nose. A good example of this approach can be seen on the character on the bottom left of the opposite page.

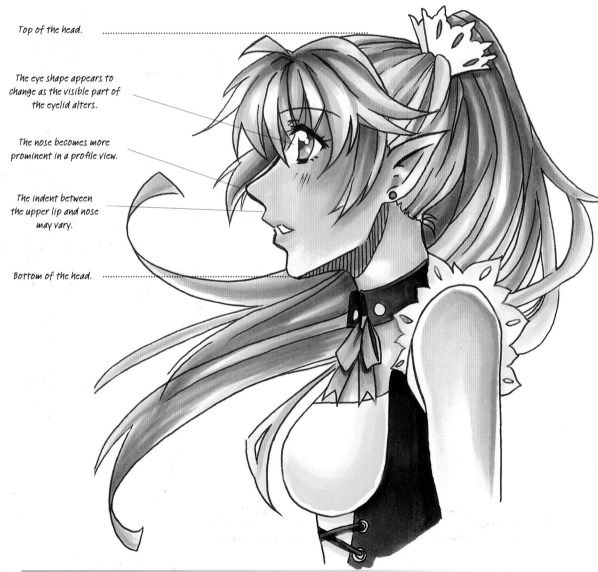

Top of the head.

The eye shape appears to change as the visible part of the eyelid alters.

The nose becomes more prominent in a profile view.

The indent between the upper lip and nose may vary.

Bottom of the head.

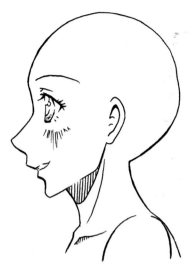

When inking the profile, indicate shadow beneath
the jaw with fine lines, as shown.

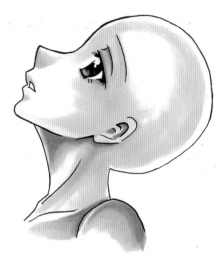

The sternomastoid is a prominent neck muscle that extends
between the collar bone to the base of the ear. It is easily visible
from the side when the head is tilted backwards.

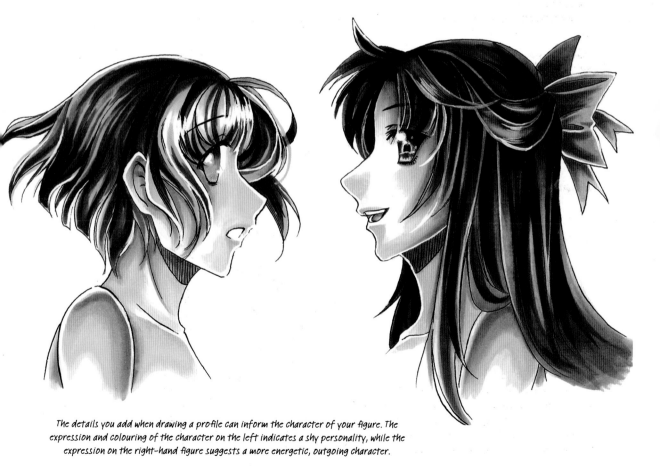

The details you add when drawing a profile can inform the character of your figure. The
expression and colouring of the character on the left indicates a shy personality, while the
expression on the right-hand figure suggests a more energetic, outgoing character.

Drawing the female face in three-quarter view

In this view, the proportions remain the same, the horizontal axis is compressed, putting the eyes closer together and making the mouth narrower. The vertical placement of the features remains the same.

In the finished example (see opposite), the eye on the right is further away from us, so it appears narrower than the eye on the left. The jaw is also compressed widthwise as well.

Although many books will teach beginners to start with a circle and cross layout, most professionals do not actually do this. This walkthrough of how to draw the face in a three-quarter will help you to better grasp the facial proportions, by laying them out as you go.

1 Start with the basic structure of the eyes. From this angle, the rightmost is further away, so draw it slightly thinner than the nearer eye.

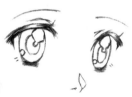

2 Add detail to the eyes and draw in the nose and eyebrows.

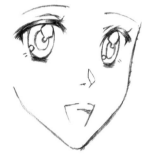

3 Now add the mouth and jawline. Build the jawline around the facial features, remembering the basic proportions for the female face (see pages 12–13).

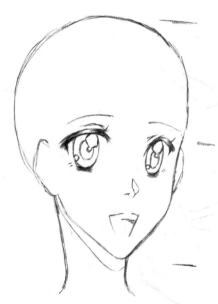

4 Build up the remainder of the head using the jawline and facial features as reference. The space between the top of the eye and the chin should be slightly less than half of the face. The lines I used here to help measure are on the right of the face.

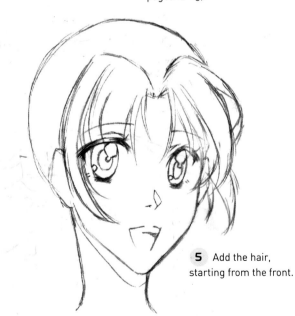

5 Add the hair, starting from the front.

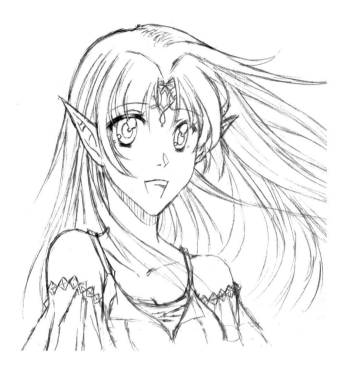

6 Develop the details on the hair, then dress as you wish. Here I have added an elfin pointed ear, and set off the face with jewellery on the forehead.

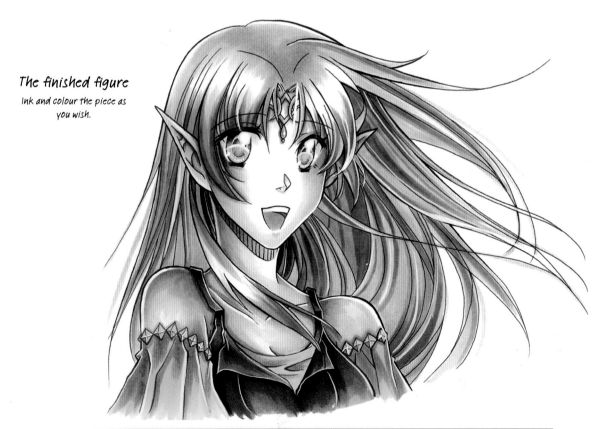

The finished figure
Ink and colour the piece as you wish.

More examples of the female face

All of these examples were drawn using the techniques on the previous pages and the proportions on page 13. Experiment and have fun!

There are many facial styles and different features that can help to show the personality of your character. Experiment with turning the tips of eyes up and down to show expression and mood as well as indicate to the viewer what kind of person your character is.

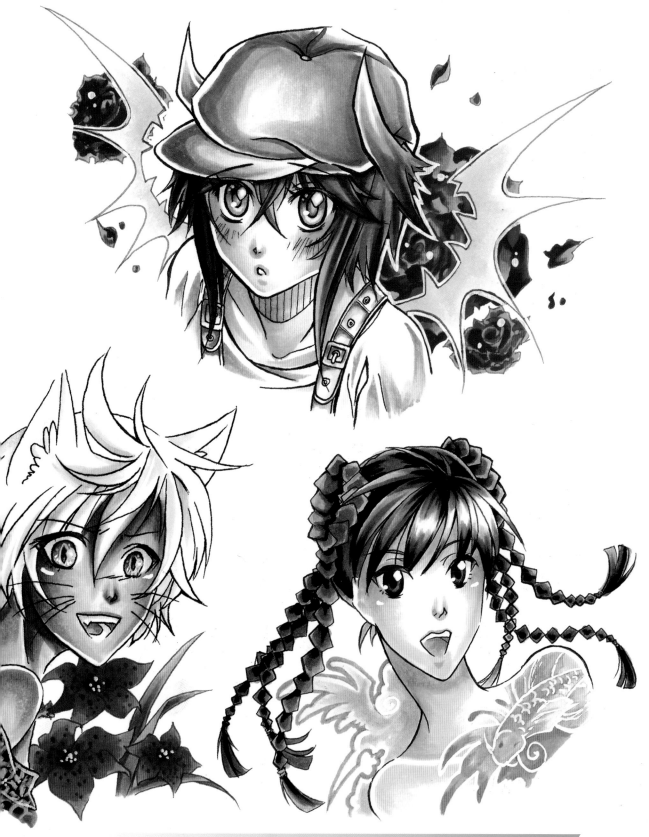

The male face

Facial features are seldom perfectly symmetrical, so it is necessary to draw out both sides, not just flip the image. The nose appears to be asymmetrical because the drawn part is actually the shadow created by the light source in the image. Note that any light shown in the eyes should also come from the same side.

For the manga style, male faces follow much the same proportions from the front as female faces. However, male features have subtle differences from their female equivalents.

TOP TIP !

Remember, manga proportions are broadly the same as realistic proportions.

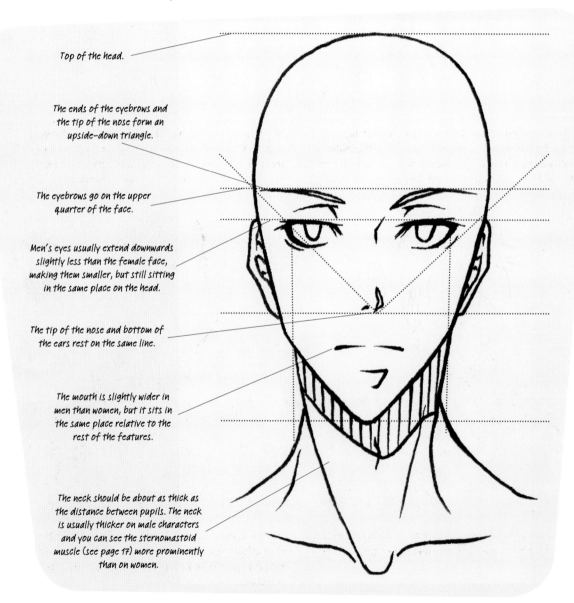

Top of the head.

The ends of the eyebrows and the tip of the nose form an upside-down triangle.

The eyebrows go on the upper quarter of the face.

Men's eyes usually extend downwards slightly less than the female face, making them smaller, but still sitting in the same place on the head.

The tip of the nose and bottom of the ears rest on the same line.

The mouth is slightly wider in men than women, but it sits in the same place relative to the rest of the features.

The neck should be about as thick as the distance between pupils. The neck is usually thicker on male characters and you can see the sternomastoid muscle (see page 17) more prominently than on women.

Drawing the male face from the front

1 Keeping the proportions opposite in mind, lay out the face. Start with the eye and nose, then draw the jawline, followed by the mouth. Extend the skull upwards to form the top of the head. Lastly, draw out the neck and shoulders.

2 Draw the hair using straight lines but with changing angles. Keep your curves soft and do not give the hair as much volume as a female would have. The lack of volume in the hair will produce a more masculine effect.

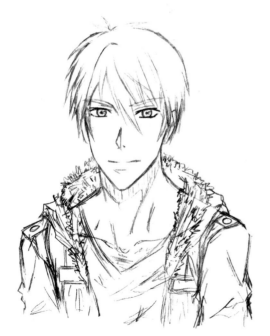

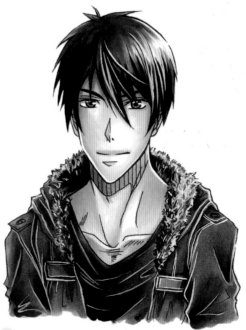

3 Extend the body down and draw in the clothing, keeping in mind the fabric type and pull of gravity.

4 Think about the main light source (see pages 112–117) while colouring. In this picture the light source is coming from the upper right so everything in this picture should reflect this.

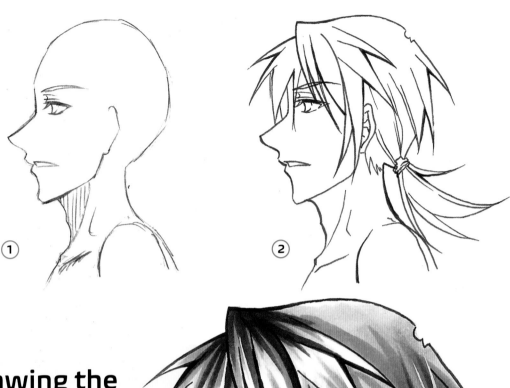

Drawing the male face from the side

1 Lay out the basic structure of the face, neck and shoulders.

2 Add the hair and ink the drawing, making sure to vary the line weight (see pages 100–103).

3 Colour in the piece, keeping in mind the light source and the mood you want to create.

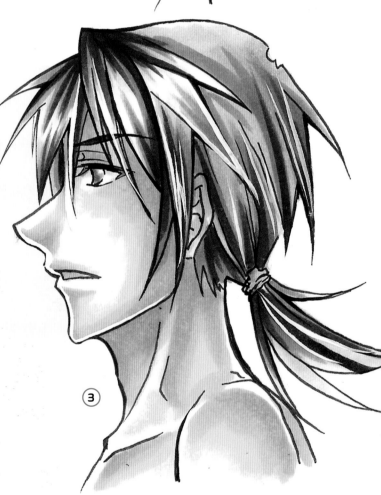

As with female faces, the proportions for the male face remain the same from the front and side. Practising drawing this will allow you to better understand angles and how to draw the face in rotation.

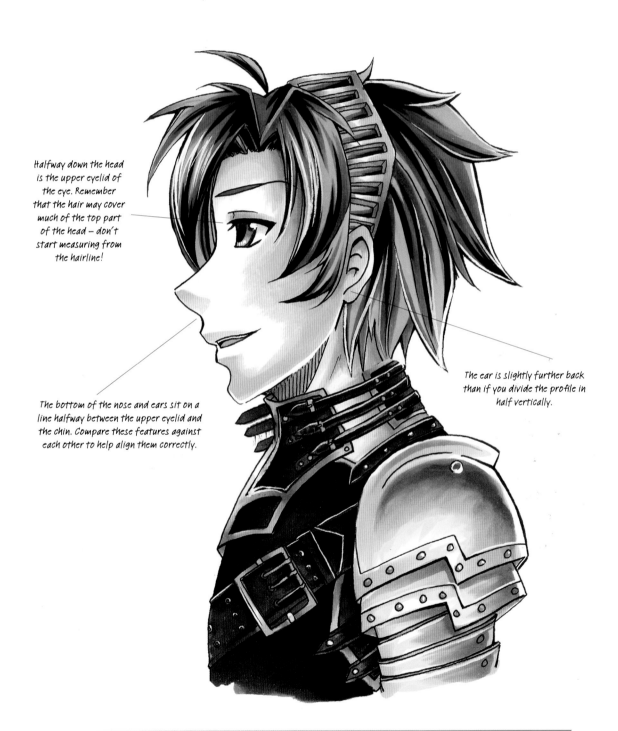

Halfway down the head is the upper eyelid of the eye. Remember that the hair may cover much of the top part of the head – don't start measuring from the hairline!

The ear is slightly further back than if you divide the profile in half vertically.

The bottom of the nose and ears sit on a line halfway between the upper eyelid and the chin. Compare these features against each other to help align them correctly.

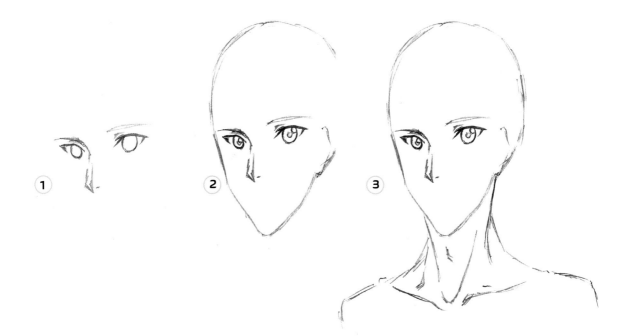

Drawing the male face in three-quarter view

1 Draw out the eyes, nose and eyebrows. Here the eye on the left is farther away so it appears shorter and the eye on the right is elongated because it is closer.

2 Build the jawline around the central features. The curve in the jaw should start around the same level as the bottom of the nose.

3 Add the neck and shoulders. Remember that the neck is thicker on men than it is on women.

4 Add the hair and clothing to finish the drawing.

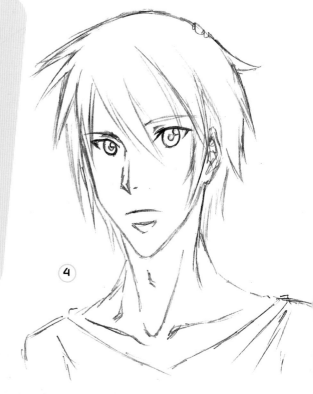

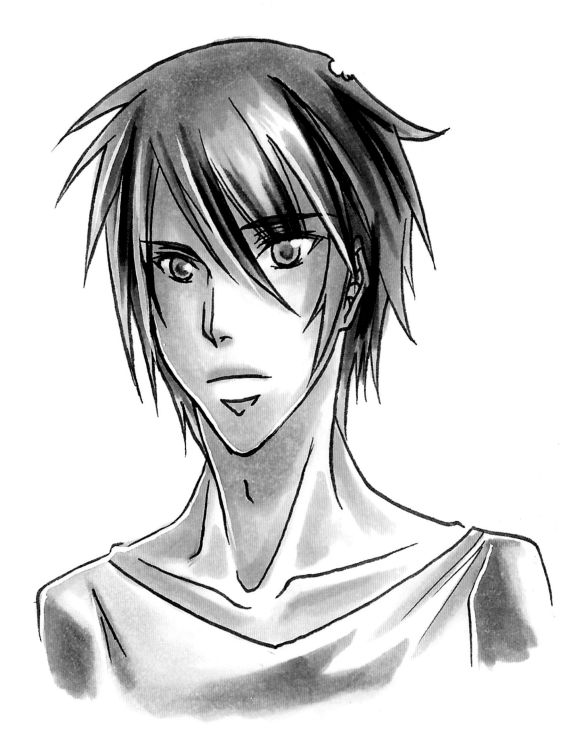

The finished figure

Ink and colour the piece, keeping in mind light sources and
reflected light. The blue light here is reflected light from the
left, but the main light source is from the right.

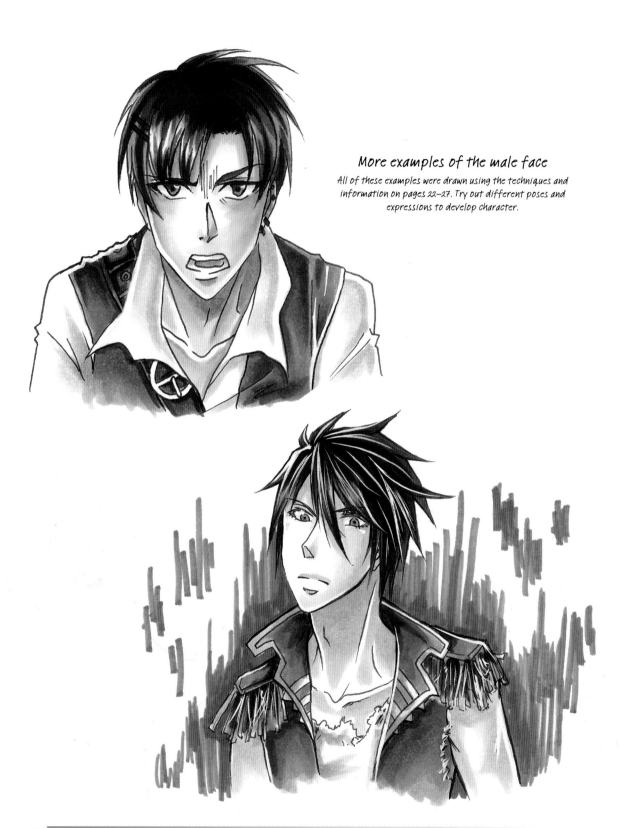

More examples of the male face

All of these examples were drawn using the techniques and information on pages 22–27. Try out different poses and expressions to develop character.

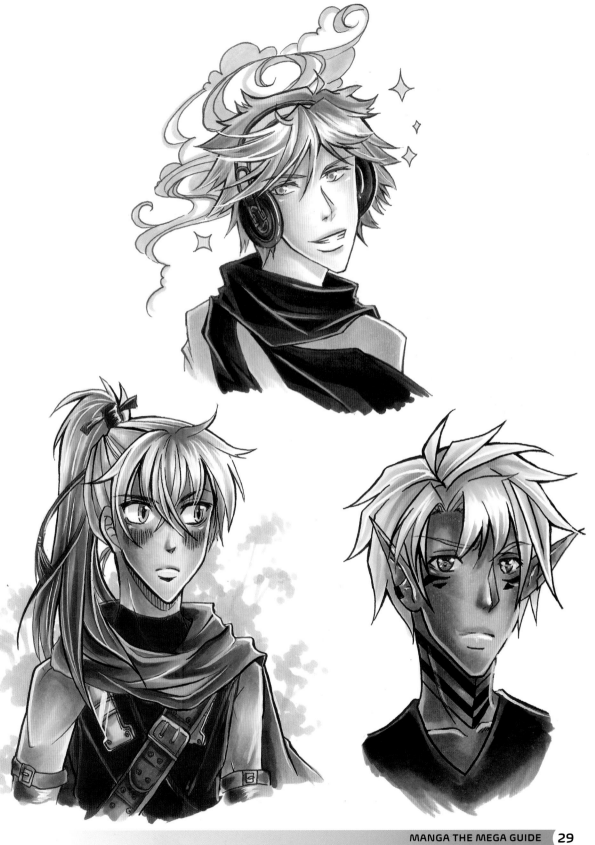

Gender and age

Male and female faces

As mentioned earlier, the facial proportions for both sexes are the same in manga art. Men have larger heads than women, but the features are centred in the same places.

The features differ in detail. Male's eyes are usually more square while females will have rounder eyes, for example. Both males and females have larger eyes, along with smaller mouths and noses, than in reality. Proportionally, however, men in manga have slightly smaller eyes and longer noses than women. In addition you can see that the mouth is slightly wider on male faces than on female faces.

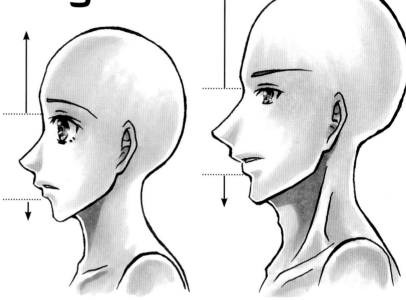

Male faces – that is, the area where the features sit on the head – are roughly the same size as female faces. However, because men's heads are bigger, their faces take up proportionally less space on the head, with more space above and below the features. This is why it is best to draw the features first, then build the rest of the head (the jaw and skull) around them.

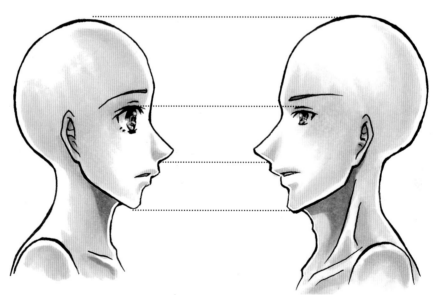

When the female head is scaled up to the same size as the male head, you can see that the facial proportions are the same. This image shows how the man has proportionally smaller eyes, a longer nose and a larger chin than the woman.

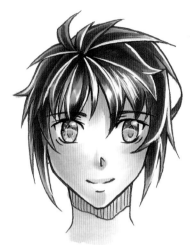

Female teen

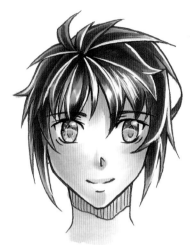

Male teen

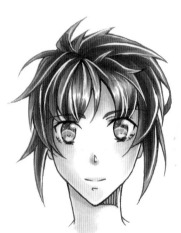

Female young adult

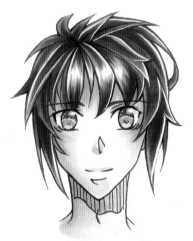

Male young adult

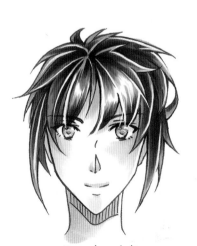

Female adult

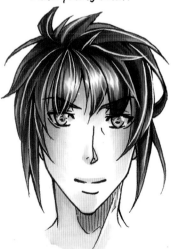

Male adult

Growing up

The images on this page show two characters – one female, one male – at different ages, from their teen years (top) to maturity (bottom). In both the man and woman, the face elongates as they age, but the proportions remain intact.

Men's chins are rounder and more pronounced, and their necks tend to show a prominent Adam's apple and sternomastoid muscle, which develops and becomes more obvious with age.

In the teens, the features are more similar, but the subtle differences in the genders gradually become more apparent as the two age.

Faces and age

As shown earlier, in manga art the upper part of the head commonly appears proportionally larger than in reality, with the facial features mostly confined to a smaller, lower part of the head. In combination with the large eyes and small nose and mouth typical of the style, this helps to give a cute, appealing look. Exaggerating this – by making the upper part of the head and eyes larger, and the lower part, nose and mouth smaller – can give a more youthful appearance.

In more realistic or older characters, the proportion between the upper and lower parts of the head are roughly even. This conveys a more serious, grown-up character.

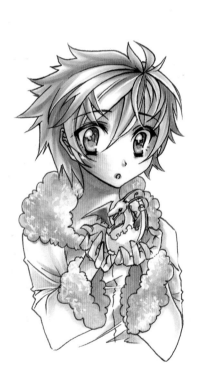

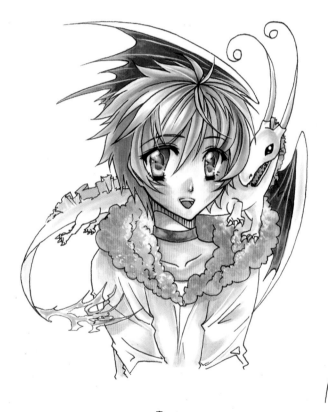

Child

Young children are easily excited and usually happy. Our young character has large eyes and an expression of wonder at her hatchling dragon.

Teen

As our character grows her face becomes longer. The features take up proportionally less space, leaving more space between the chin and eyes as well at the top of the head. Our little dragon gets bigger too.

Ageing the same character

When drawing the same character at different ages, as shown on these pages, it is important to have your character design set before you begin so that you can keep the character recognisable as their features alter.

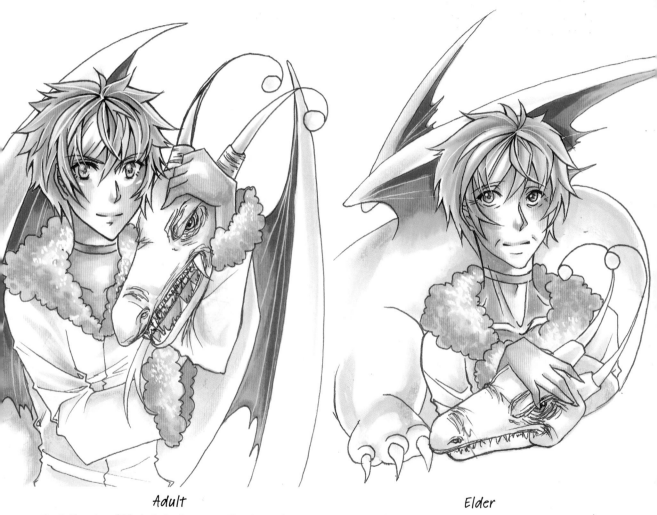

Adult

Now in the prime of life, both the character and her dragon show satisfied expressions. More determination in the expression and less cuteness in the features help to show maturity and calmness. Remember that attitude is a huge part of growing older.

Elder

In old age, wrinkles appear around the eyes and edges of our character's mouth, while the dragon becomes aggressive and protective of his owner.

Male and female

Shown here is the same character rendered as both male (left) and female (right) to help illustrate the subtle differences between gender in manga art. Females generally have larger eyes and a smaller face as well as broader hips and more slender shoulders.

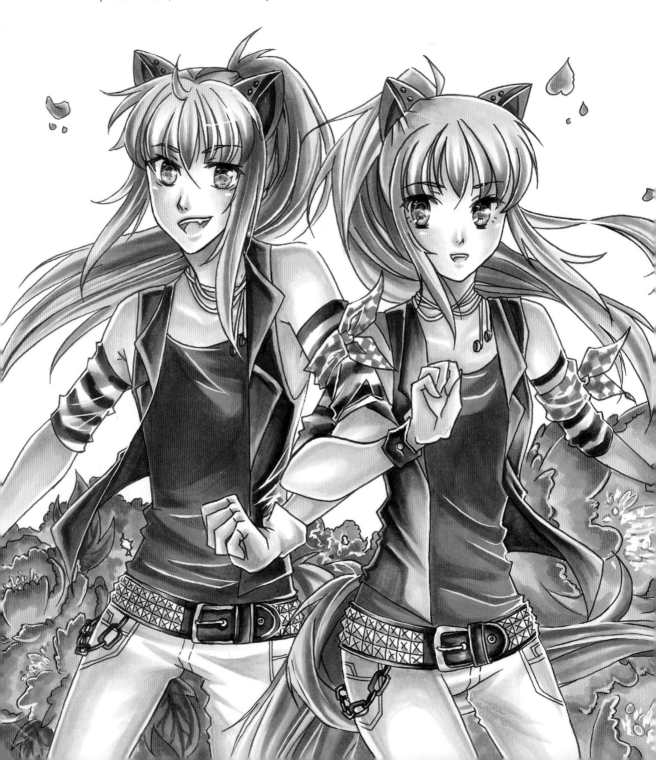

Androgynous figures

Androgynous characters typically have features of both genders and neutral body types. You can see on this character that the eyes and mouth are more feminine, but the body, neck and nose have more masculine characteristics.

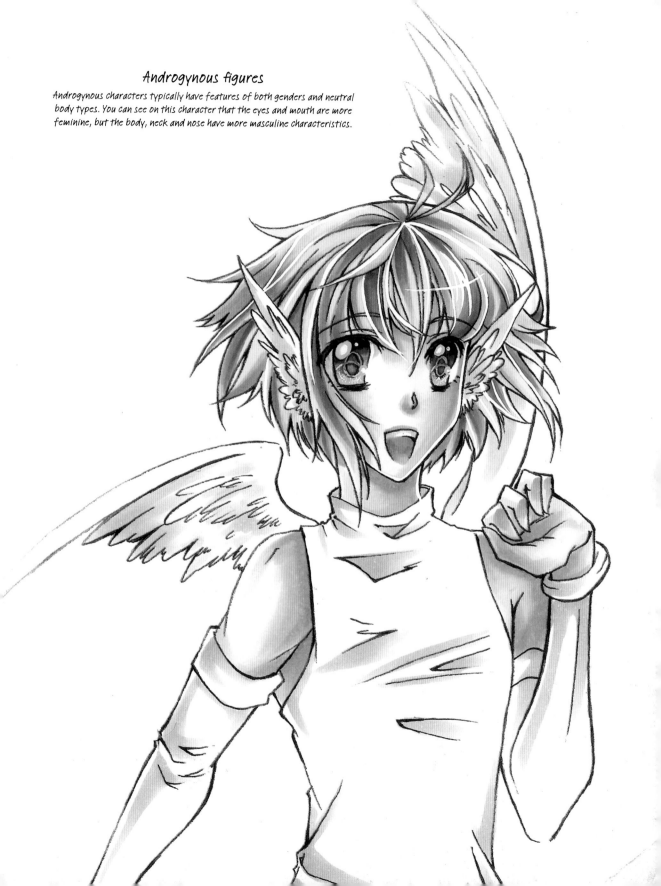

Expressions

Facial expressions are very important to our art. It is how we can communicate emotion to those who view our work. Aim to always invest your characters with emotion and avoid drawing emotionally neutral characters. The stronger the emotions you convey the better you will touch your audience. If you do not vary your characters' expressions, they will seem empty and flat.

Emotions and the face

The head is the focal point of the figure, so it is important that we invest our characters' faces with emotions by varying the facial features.

When drawing emotions pay particular attention to the eyebrows. Do not draw them as a simple arch or you will lose the chance to better emphasise the emotions.

Happiness

To show that a character is happy, raise the eyebrows so that they are higher in the middle, and draw the eyes and mouth wide open.

Embarrassment

An embarrassed look is very similar to anger, though the features will be less harsh and a heavy blush will appear on the face. The mouth will usually be slightly open, but not showing teeth.

TOP TIP !

Realistic, three-dimensional characters need to have faults and bad personality traits as well as virtues. Practising different expressions to convey these will help you to improve as an artist.

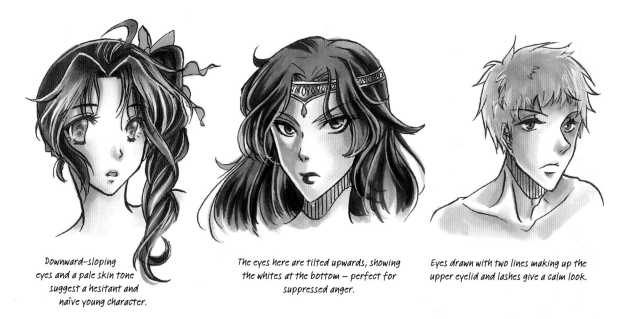

Downward-sloping
eyes and a pale skin tone
suggest a hesitant and
naïve young character.

The eyes here are tilted upwards, showing
the whites at the bottom – perfect for
suppressed anger.

Eyes drawn with two lines making up the
upper eyelid and lashes give a calm look.

Avoid similarity

'Same face syndrome' – where all your drawings have identical facial features and expressions, and the only differences between them are the hairstyles and clothing – is an easy trap to fall into, and it can make your characters dull and boring. To avoid it, practise different ways of drawing eyes, noses and mouths and be sure to vary the expression and emotions you put onto your figures' faces. The examples on these pages will give you some starting points, and you can practise copying your friends' faces and expressions.

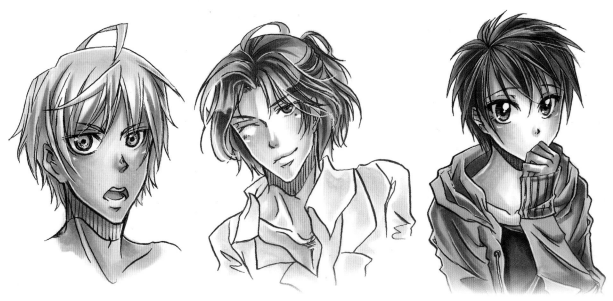

Bright eyes, tanned skin and making
the upper and lower eye lashes
connect differentiate this face
from the others shown here.

Using three lines on the upper eyelids and
lashes gives the eyes a slightly hooded, flirty
appearance, enhanced by this character's
smirking mouth.

Large eyes, a sidelong gaze and
closed body language add to this
character's shy expression.

Pose and emotion

Where your characters are looking will affect how their emotions are perceived. Downcast faces looking away from the viewer help to convey a character's sadness. Surprised characters will be looking at what caused the reaction. Having angry, aggressive characters look directly at the viewer will amplify the emotion.

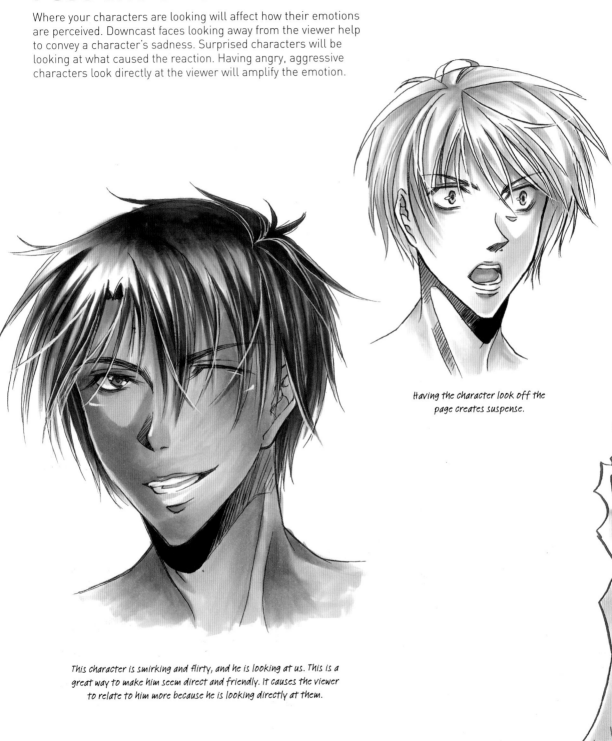

Having the character look off the page creates suspense.

This character is smirking and flirty, and he is looking at us. This is a great way to make him seem direct and friendly. It causes the viewer to relate to him more because he is looking directly at them.

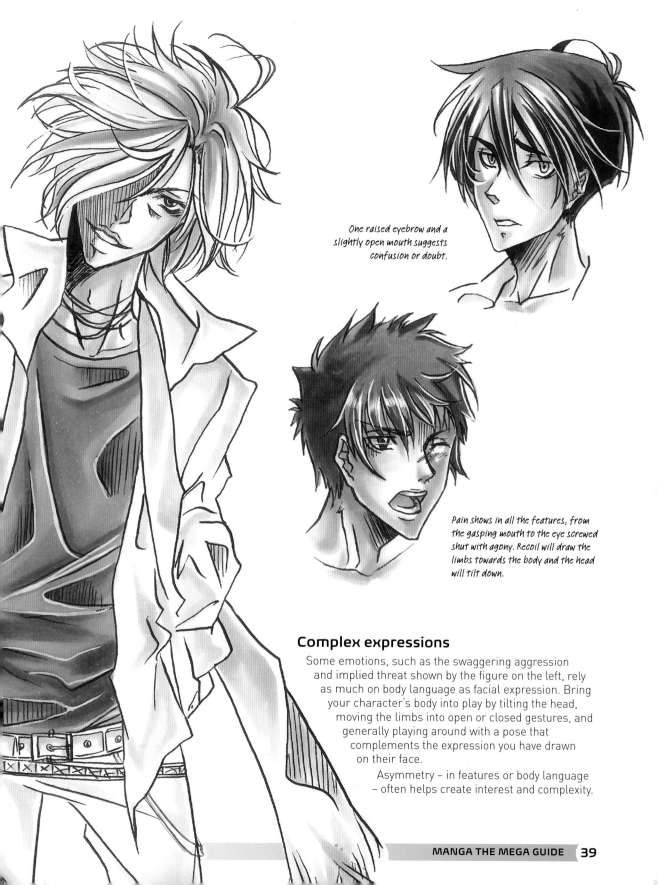

One raised eyebrow and a slightly open mouth suggests confusion or doubt.

Pain shows in all the features, from the gasping mouth to the eye screwed shut with agony. Recoil will draw the limbs towards the body and the head will tilt down.

Complex expressions

Some emotions, such as the swaggering aggression and implied threat shown by the figure on the left, rely as much on body language as facial expression. Bring your character's body into play by tilting the head, moving the limbs into open or closed gestures, and generally playing around with a pose that complements the expression you have drawn on their face.

Asymmetry – in features or body language – often helps create interest and complexity.

Eyes

Eyes are incredibly important in communicating expression and emotion, and this is doubly true for the exaggeratedly large eyes used in the manga art style.

In manga, men's eyes tend to be significantly smaller and closer to realistic proportions than women's eyes. This is because larger eyes are considered 'cute' in Japan, so to make women and young people cuter the eyes are exaggerated in size. Young boys will often have large eyes, but adult and older men, who are meant to look more serious, will have eyes and irises significantly smaller than those of a cute young girl. If you want to draw a serious older women, then the eyes will be smaller as well.

Make sure to vary the eye types, expressions and angles you use for your characters to avoid having them all look the same.

Eyes and age

Eyes are the biggest tell of age throughout life. They will gradually become thinner as the character ages, as the eyelids become thicker and heavier. Towards the end of life crow's feet and wrinkles develop around and under the eyes.

Child

Children's eyes are very open, with large irises, and lots of light is reflected.

Adult

Heavier eyelids make the eyes appear narrower and reduced in height. Less light is reflected.

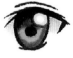

Teen

Light is still prominent in teenage eyes and the large iris remains visible, but both are beginning to decrease.

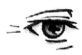

Elder

Wrinkles appear and eyes are closed further, producing a tired look.

Female eyes

The examples here show different eye styles for you to try.

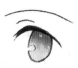 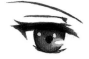 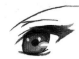

Suspicious sidelong glance

Interested

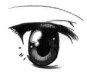 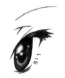 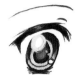 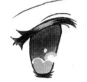

Direct gaze

Shock or sudden realisation

Innocence

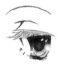 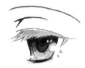 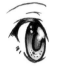 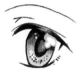 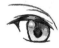 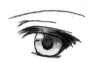

Thoughtful

Friendly and open

Calculating

Male eyes

Men's features are usually more subtle in changes than females, but it is very important to vary them to show personality.

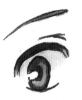 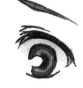 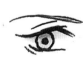 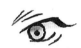

Frightened panic

Disapproval

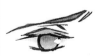 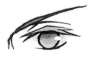 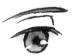 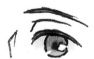 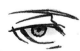

Disbelieving or suspicious

Neutral gaze

Seductive

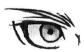 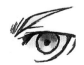 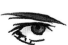 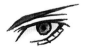

Alert

Sneaky

Angry

Hair

It can be tricky to ensure that hair is properly positioned on the head – and that's before we even talk about partings and styles! Luckily, there are some good ways to help you draw and place hair convincingly, which are shown on these pages.

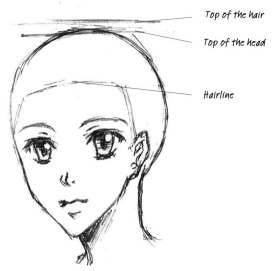

Top of the hair

Top of the head

Hairline

Guidelines

You can add some guidelines to help you position the hair, as shown to the right. Draw a faint line roughly halfway between the top of the eyes and the top of the head to indicate the start of the hairline.

Secondly, because hair is added on top of the skull, adding hair will increase the volume of the head. You can add faint guidelines to mark both the top of the head and the top of the hair. These will help you as you place the shapes that make up the hair itself.

Shapes in the hair

Try to identify shapes within the mass of the hair rather than trying to add each individual strand one at a time.

When you start to see combined strands and locks of hair, think of them as ribbons that fold and turn back on themselves. Drawing the flat surfaces of these 'ribbons' will help you work out how they curve and twist around each other, and add depth to your figure's hair.

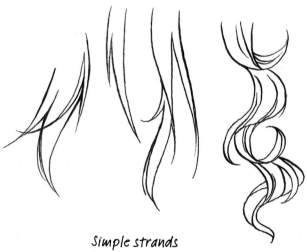

Simple strands

Strands of hair appear finer and pointed at the ends of locks like these as there are fewer individual hairs adding to the volume. Ink these more thinly to enhance the tapering effect.

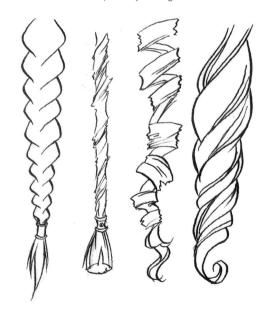

Braids

Here are some examples of different styles of braid. There are many more, so choose the style that suits your character the best.

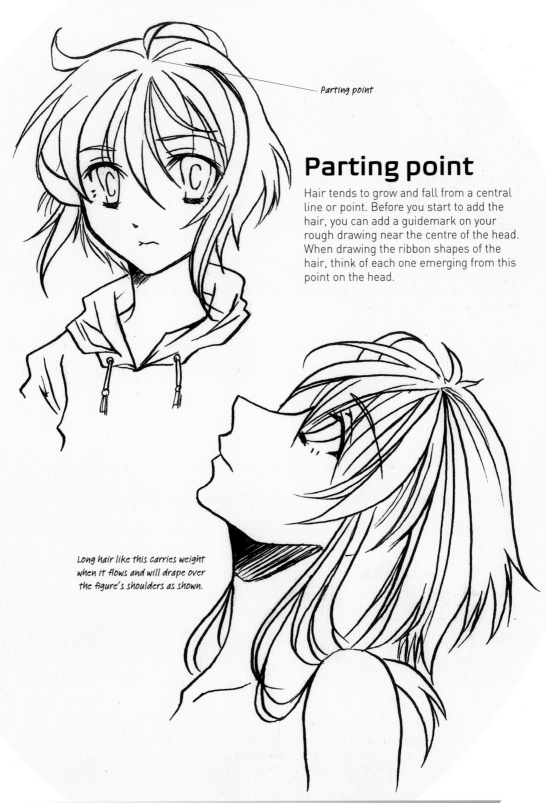

Parting point

Parting point

Hair tends to grow and fall from a central line or point. Before you start to add the hair, you can add a guidemark on your rough drawing near the centre of the head. When drawing the ribbon shapes of the hair, think of each one emerging from this point on the head.

Long hair like this carries weight when it flows and will drape over the figure's shoulders as shown.

Drawing hair

Here is a basic walkthrough of drawing a simple hairstyle. Imagine the hair in larger chunks that connect at the parting. This will help you to create the overall shape and form of the hair; then you can break it down into smaller and more detailed sections.

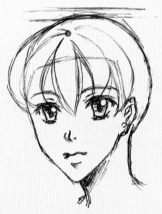

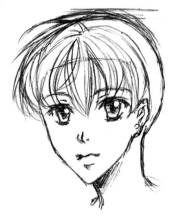

1 Draw the head and face, then add your guidelines and marks – the hairline, volume mark and parting point.

2 Draw in the basic shapes of the hair falling over the forehead.

3 Add some loose individual strands in and around the larger shapes.

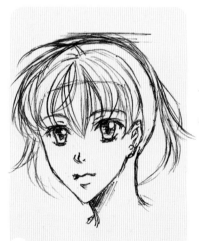

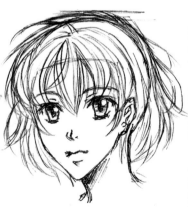

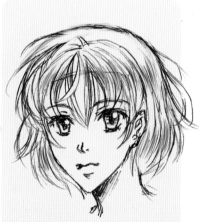

4 Draw in the basic flow of the bottom layer of hair.

5 Again, add more lines and details around this part of the hair.

6 Erase the guidelines and some of the lines on the top part of the hair to suggest highlights.

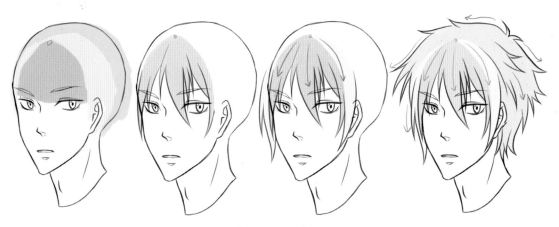

Three-part hair

It may help you to envision hair as divided in three distinct sections:
front, sides and middle. This will let you focus on each set as a chunk
rather than getting overwhelmed by drawing the whole head of hair.

The examples on this page have the different parts coloured in blue, yellow
and green to show you how this approach works with different hairstyles.

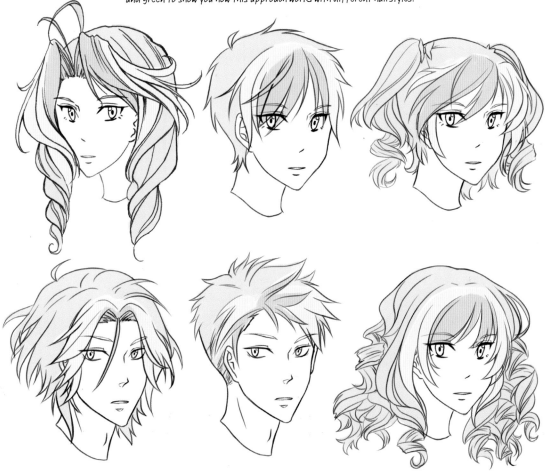

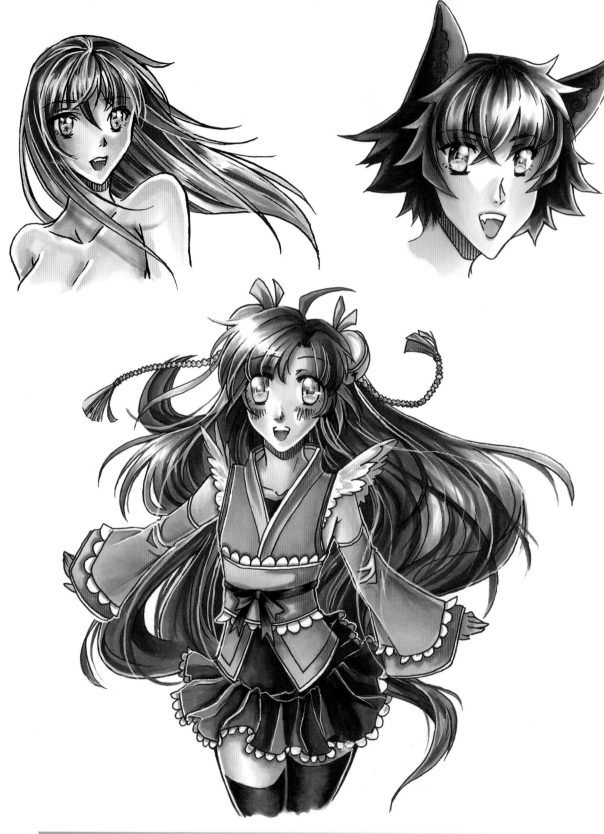

More examples of hair

Hairstyle says a lot about your characters. It can make them appear cute and energetic, loud and obnoxious or even quiet and meek. When drawing hair, make sure that it matches the character's expression. For example, even though you are drawing the same style, a character's hair may have more movement when a character is happy, and seem weighed down and flatter when in a sad or glum mood. Hair can also be used to guide the viewer's eye across the page, so think about the feel of the whole image when drawing the hair.

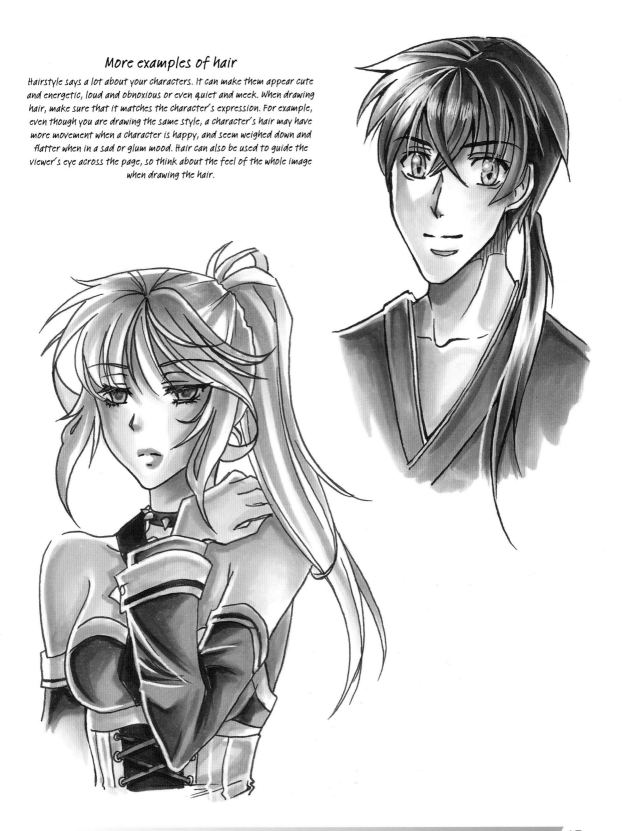

DRAWING THE FIGURE

We've learned how to draw the heads and faces of our characters, as well as how to give our figures different expressions and hairstyles. This part of the book will show you how to put these elements together with bodies so we can create convincing full figures in the manga style.

Basic figures

Anatomy is one of the hardest things to master when drawing manga, so I am going to teach you a simplified version. By showing you only what you need to know, you will not get bogged down in too much information. Instead of trying to memorise every last muscle in the human body, focus on learning the muscles that are on top and the bones that protrude.

Muscles generally operate in pairs and work together. They fit together like pieces of a puzzle, so you can pose them however you like once you becomes used to the patterns they form. Knowing the underlying anatomy is useful for realism, but you really only need to consider the muscles on top, because those affect what you see, and therefore what you need to draw. You will quickly pick up how the dips and folds the visible muscles create in the form change as you look at them from different angles. Think of anatomy in terms of these basic muscle sections and shapes, and you will quickly be on your way to drawing a perfect figure.

These pages will show you how to draw the form of your figure using large basic shapes to work out the proportions of your characters' bodies. The lessons we learned earlier about drawing the head and face will help to make this familiar.

Both of these figures are drawn in my preferred 1:8 head to body ratio (see page 50).

TOP TIP !

Drawing from fashion magazines and photographs is a great way to learn, but make sure to adapt and draw them in your own style, rather than simply copying them.

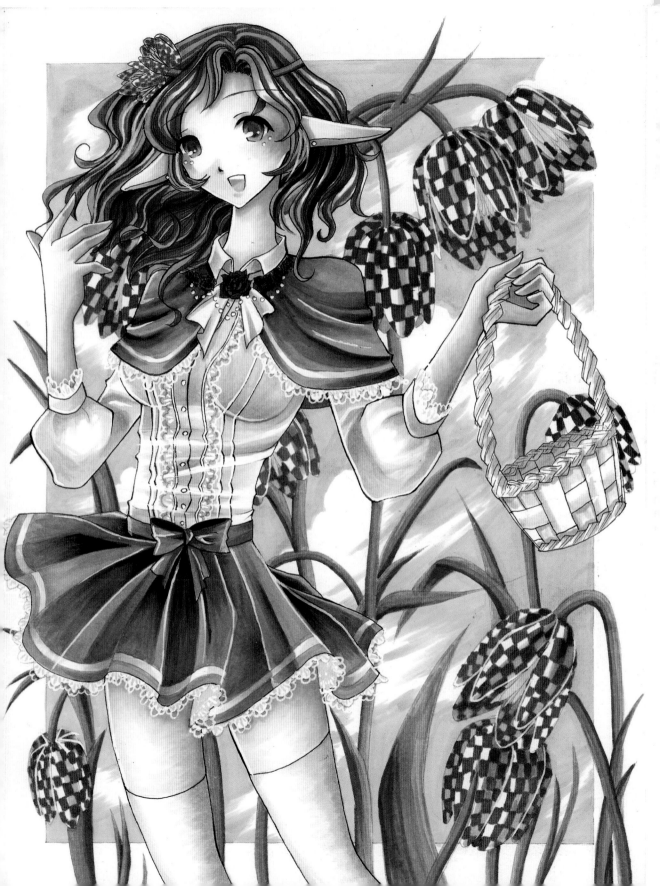

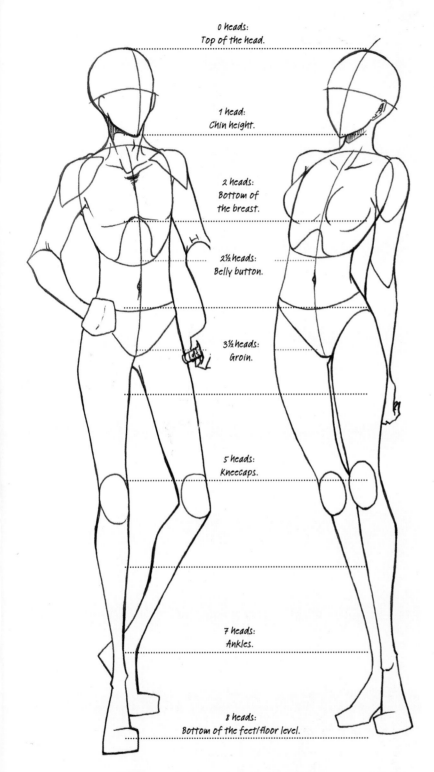

0 heads:
Top of the head.

1 head:
Chin height.

2 heads:
Bottom of
the breast.

2½ heads:
Belly button.

3½ heads:
Groin.

5 heads:
Kneecaps.

7 heads:
Ankles.

8 heads:
Bottom of the feet/floor level.

The head to body ratio

The easiest way to draw a figure accurately is to use a head to body ratio to guide you and help with the proportions of the body. This means to compare the length of different points on the body with the height of the head. For example, the kneecaps sit five heads below the top of the head in a 1:8 figure, as shown on these pages.

To use the head as the basis of your figure, draw out the basic shape of the head. Measure the height of the shape, then add guidelines of the same distance down the body, as shown in the illustrations here. This helps you check that certain significant points, such as the kneecaps or chest, are the right length and in the right place.

Proportions and style

Most of my artwork uses the head to body proportions of 1:8 shown here, which means that the figure as a whole is equal in height to eight times the distance from the top of the head to the chin. This gives proportionally longer legs than in more realistic proportions. For a less stylised look, you could use proportions nearer to 1:6½ for an adult. We will look at how to use different proportions for iconic manga styles overleaf.

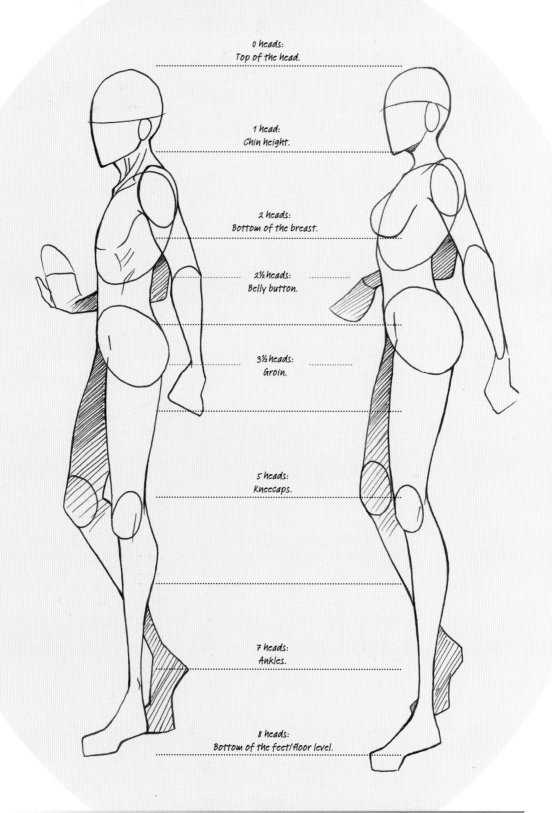

0 heads:
Top of the head.

1 head:
Chin height.

2 heads:
Bottom of the breast.

2½ heads:
Belly button.

3½ heads:
Groin.

5 heads:
Kneecaps.

7 heads:
Ankles.

8 heads:
Bottom of the feet/floor level.

Manga body proportions

Figures in realistic art have a head to body ratio of 1:6½ (i.e. the body is equal in height to six and a half heads). The head to body ratio varies greatly in manga, from chibi style (see page 88), where the ratio may be 1:1 or even smaller, all the way up to exaggerated proportions of 1:9, which gives a slender, slightly elongated look.

Choosing to alter proportions is a stylistic choice, but to do this effectively, you must first understand the basic proportions so that you know how to elongate them correctly.

Different proportions

The head to body ratio will change if you make your character younger or older (or into a chibi), but this will not affect the overall body structure. Your figure's structure will remain the same regardless of the height of the character – so the chest, hips and so forth will always fall in the same places along the body, and will always remain proportionally similar to one another: the waist will sit in the centre of the body, for example, and the arms will be long enough for the hands to rest just below the waist, regardless of the actual size of the body or head.

To illustrate this, these pages show the same character drawn in a number of different head to body ratios. Notice how the lengths of the limbs and torso alter compared with the head in the different styles, but remain proportionally similar to each other.

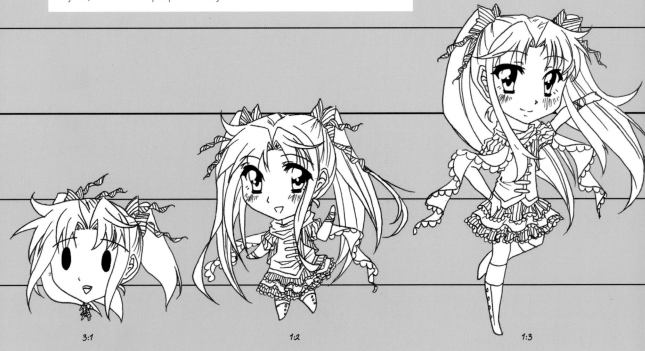

3:1

1:2

1:3

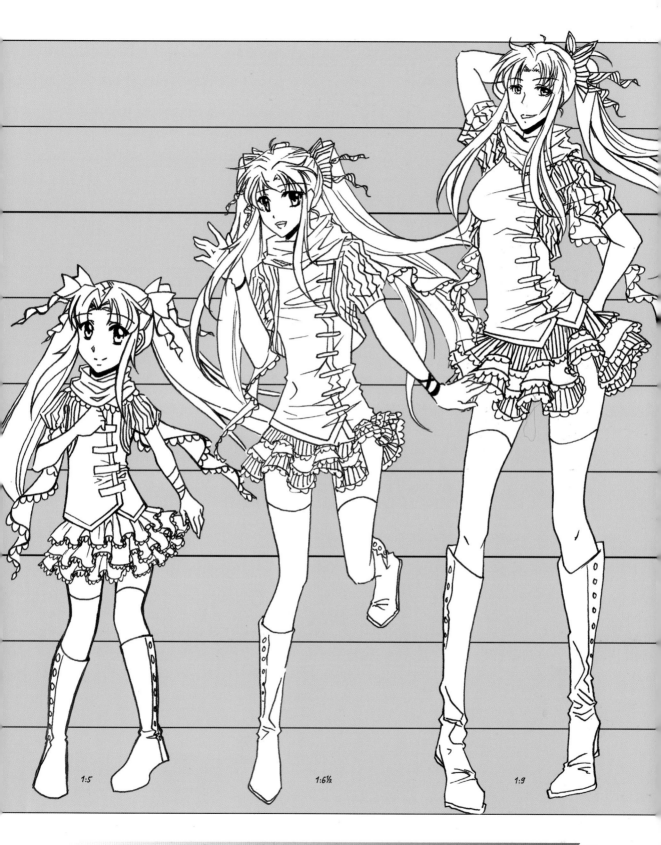

1:5

1:6½

1:9

The torso

The torso is the central part of your figure, and it is easy to think that it is unimportant compared with the arms and legs. However, drawing the torso accurately will ensure your characters appear realistic and will also provide the opportunity to add a surprising amount of character and personality.

Drawing the torso and head

When drawing complete figures it is very important to start with the torso, rather than the head. This will allow you to get a better grip on the body's proportions while you draw. Drawing this way makes it easier to balance the whole figure, and creates a solid 'core' for you when adding limbs, clothing and details.

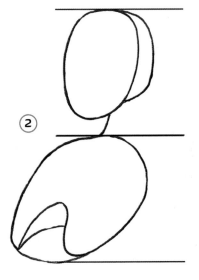

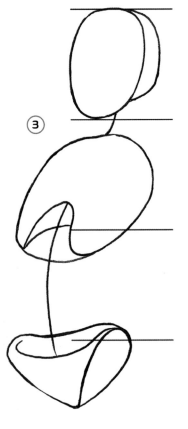

1 Start by drawing the upper torso – the shape is suggested by the ribcage.

2 The ribcage is the same length as the neck and head combined, so measure upwards to determine where the top of the head should go, then draw it in.

Making decisions on proportions

Because proportions in manga art can vary, there is no single correct way to draw your figures. However, you should make a decision on the head to body ratio you want to use and bear it in mind as you draw.

3 With the head in place, you can now use the head height to measure down and lay out the proportions for the rest of the body, using the information on pages 50–51 and opposite.

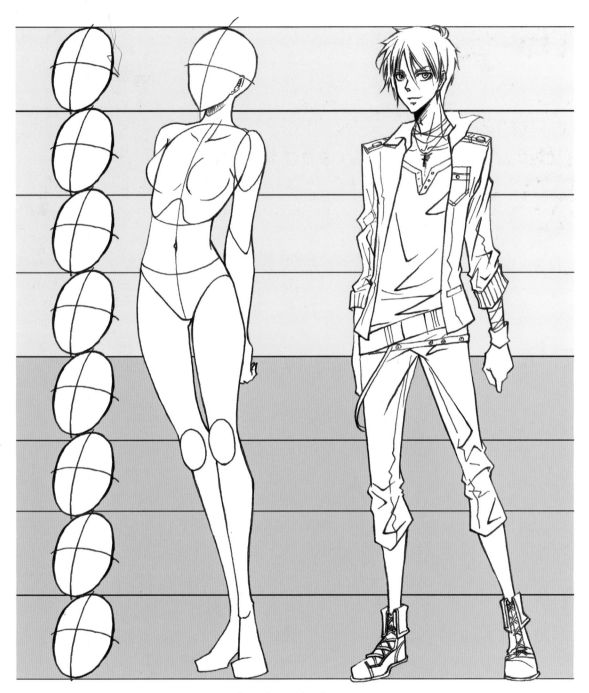

Finishing the figure

With the torso in place and the head height established, you can add the limbs in whatever pose you like. The image above shows one way that you could finish the core body, along with a more finished example in a different pose. Note how I have drawn a series of heads on the left to help check the ratio as I worked.

The torso in detail

These pages show a complex and realistic series of torsos, which may look a little intimidating. Don't worry – you don't need to learn the name of every muscle by heart! Instead, concentrate on the basic shapes of the torso you want to draw and copy it as accurately as you can. Next, adjust the shapes by simplifying them to get the clean lines of the manga style. After that, you are ready to practise until you have mastered drawing the torso in various poses and shapes. As with everything, careful observation will improve your drawing – remember the lessons of 'copy, adjust, master' earlier.

Your figure's clothes will be affected by where and how they hang from the torso. When you understand how the body works, you will quickly be able to identify how the clothes should look on it.

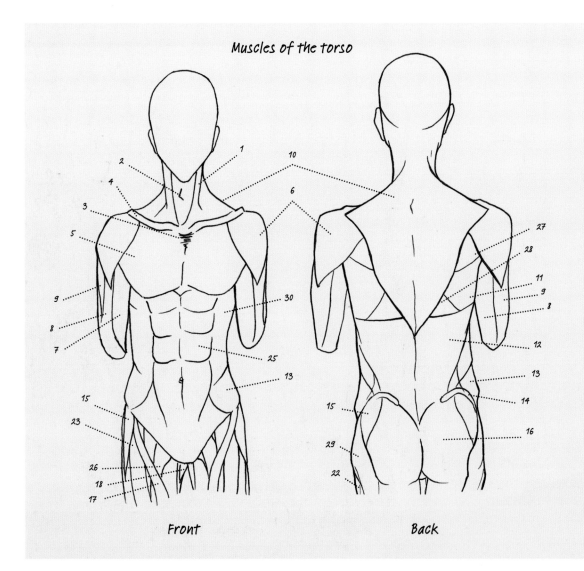

Muscles of the torso

Front

Back

1 Sternomastoid	11 Teres major	21 Vastus externus
2 Adam's apple (laryngeal prominence)	12 Latissimus dorsi	22 Iliotibial tract
3 Breastbone (sternum)	13 Transverse abdominis	23 Rectus femoris
4 Collarbone (clavicle)	14 Iliac crest	24 Coracobrachialis
5 Pectoralis major	15 Gluteus medius	25 Abdominals
6 Deltoid	16 Gluteus maximus	26 Adductor longus
7 Biceps (cubiti)	17 Sartorius	27 Infraspinatus
8 Triceps long head	18 Gracilis	28 Rhomboid major
9 Triceps lateral head	19 Tensor fasciae latae	29 Tensor fasciae latae
10 Trapezius	20 Vastus internus	30 Serratus anterior

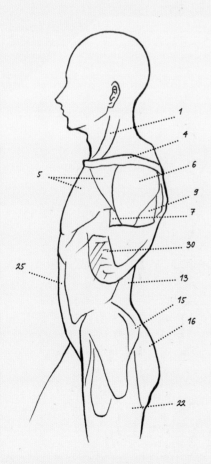

Side

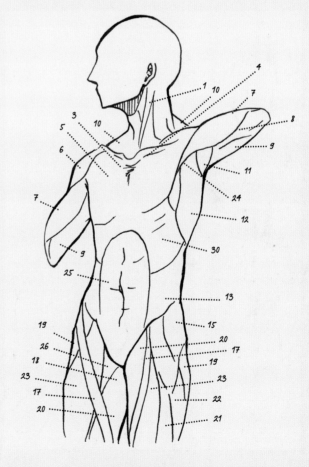

Three-quarter view

Torso differences between genders

Children's torsos are very similar regardless of sex, but adults differ in proportion. Female figures have hips wider than their chests, but in men the opposite is true. Here I use the head to body ratio to show the proportions and where they should fall. It should also be noted that the thinnest part of the waist should be no thinner than the thickness of the head.

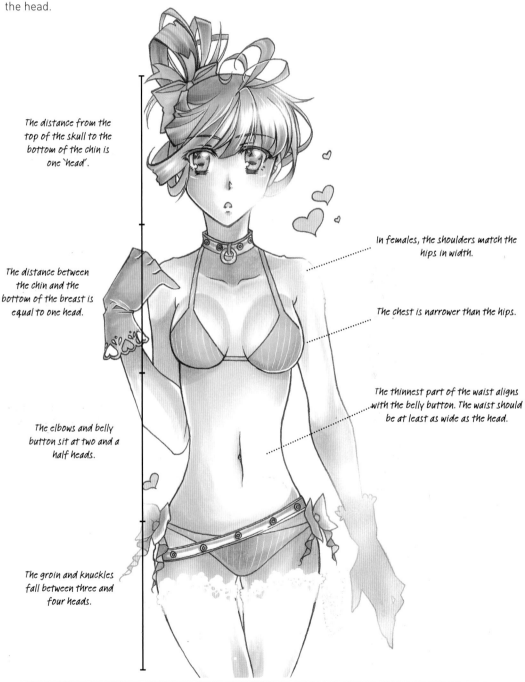

The distance from the top of the skull to the bottom of the chin is one 'head'.

The distance between the chin and the bottom of the breast is equal to one head.

The elbows and belly button sit at two and a half heads.

The groin and knuckles fall between three and four heads.

In females, the shoulders match the hips in width.

The chest is narrower than the hips.

The thinnest part of the waist aligns with the belly button. The waist should be at least as wide as the head.

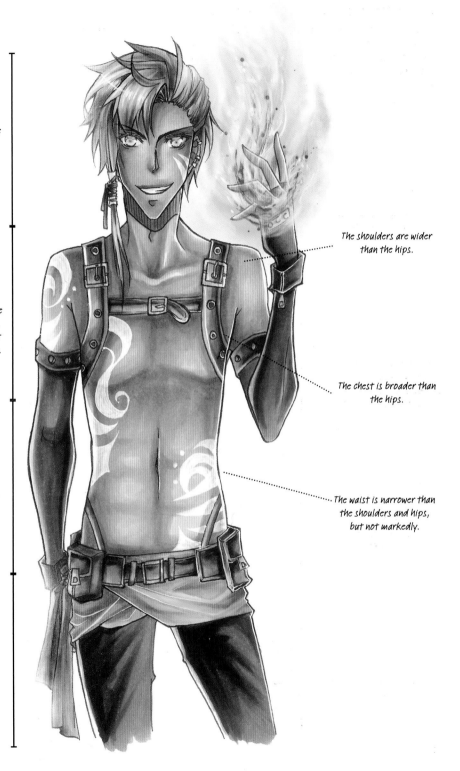

Although the head is longer than the woman's opposite, we still use it as the basis of the figure's proportions.

The longer head means that the man ends up taller, but the proportions remain the same. The bottom of his upper chest is still one head from the chin.

The shoulders are wider than the hips.

The chest is broader than the hips.

The waist is narrower than the shoulders and hips, but not markedly.

Hands and feet

Now that we have learned how to draw the head and torso, we can move on to hands and feet – and of course arms and legs. A lot of the lessons we learned earlier apply here, and as always practice will help you to copy, adjust and master these important parts of the figure.

While not as important as the head and face, feet and hands help to show your figure's character and emotions. When you learn how to draw your figures holding something, you open up a whole world for them.

Hands

Hands and feet are complex forms when compared with heads, because they involve lots of joints in the wrist, the thumb and the fingers. However, the basic structure of the hand is easy to draw if broken down into smaller shapes as described on page 62.

Rather than treating each finger individually, the fingers can be broken down into an oven mitt shape and, regardless of the angle, the palm and wrist can be drawn with six construction lines to help you make sense of the form. These construction lines are shown in blue in the examples below and on the following pages.

TOP TIP !

Think in three-dimensional form rather than two-dimensional shapes when drawing hands and feet – this will help make your art more believable and will help you to more easily understand what it is that you are drawing.

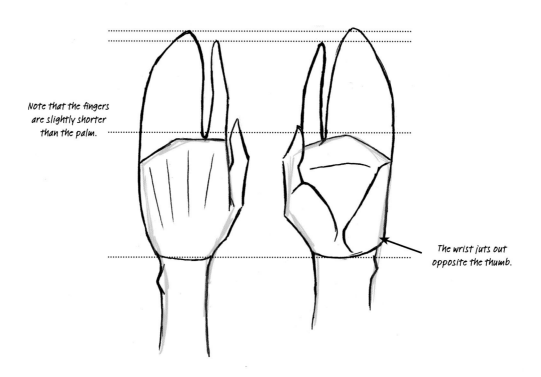

Note that the fingers are slightly shorter than the palm.

The wrist juts out opposite the thumb.

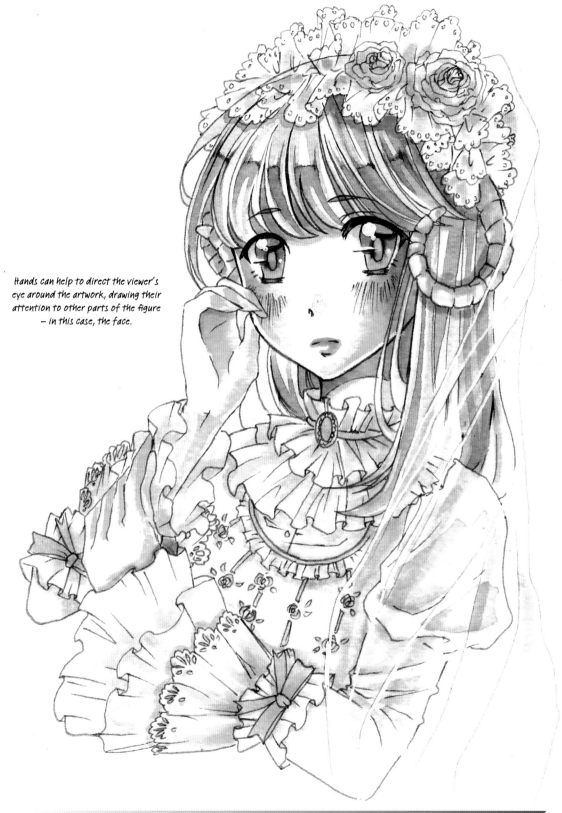

Hands can help to direct the viewer's eye around the artwork, drawing their attention to other parts of the figure — in this case, the face.

Understanding the shape of the hand

To draw something correctly you must first understand it. For example, you may find it helps to think of the wrist and hand as two separate boxes that twist and connect together. They interlock and wedge together to create the solid structure of the hand.

Drawing out and understanding the planes that exist on the hand will help you greatly with your drawing and – more particularly – colouring. The separate shapes in the hand can be simplified into boxes and wedges to make them easier to draw.

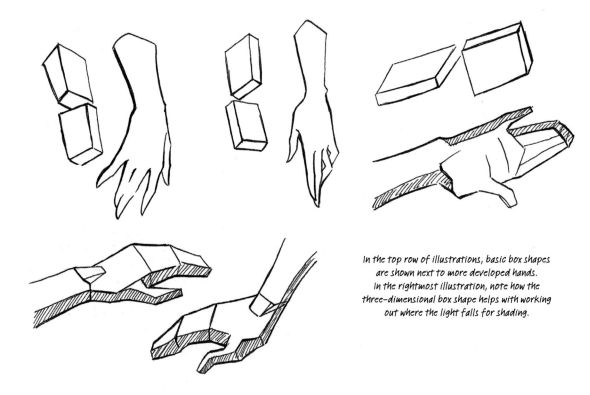

In the top row of illustrations, basic box shapes are shown next to more developed hands. In the rightmost illustration, note how the three-dimensional box shape helps with working out where the light falls for shading.

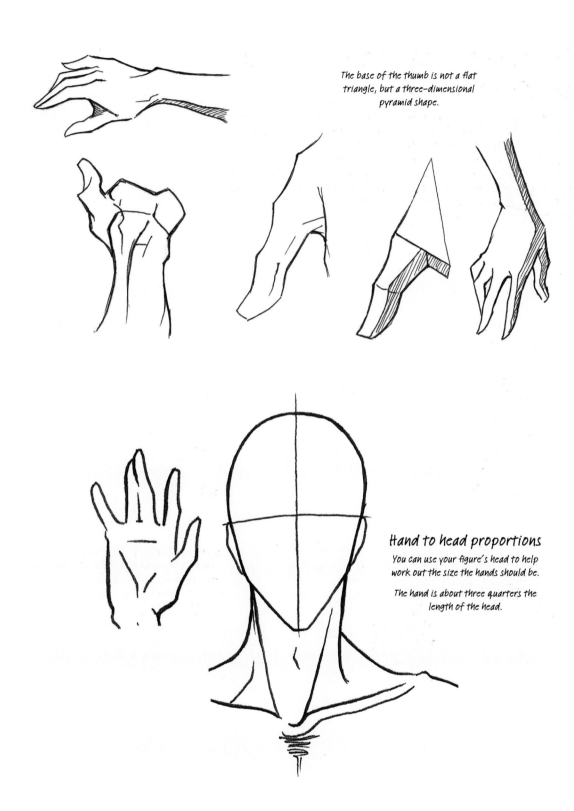

The base of the thumb is not a flat triangle, but a three-dimensional pyramid shape.

Hand to head proportions

You can use your figure's head to help work out the size the hands should be.

The hand is about three quarters the length of the head.

Hands in motion

Practise drawing hands from lots of different angles, and include lots of motion to make your pictures more dynamic. The examples on these pages show lots of different poses for the hand for you to copy and practise.

Muscles move in groups and each movement of one set causes other sets to react. For this reason, hands are said to have an action and inaction side to each pose, which refers to the way the hand is bending at the wrist. The side that the hand bends towards is called the action side because those muscles are the ones in action. The inaction side is the opposite side, where the muscles are relaxed and not being flexed.

Inaction side

Action side

The six lines of basic structure

The structure of the palm and wrist can be drawn in any angle and any pose using just six lines, highlighted in these examples with blue lines. Use this structure to help guide you when drawing hands.

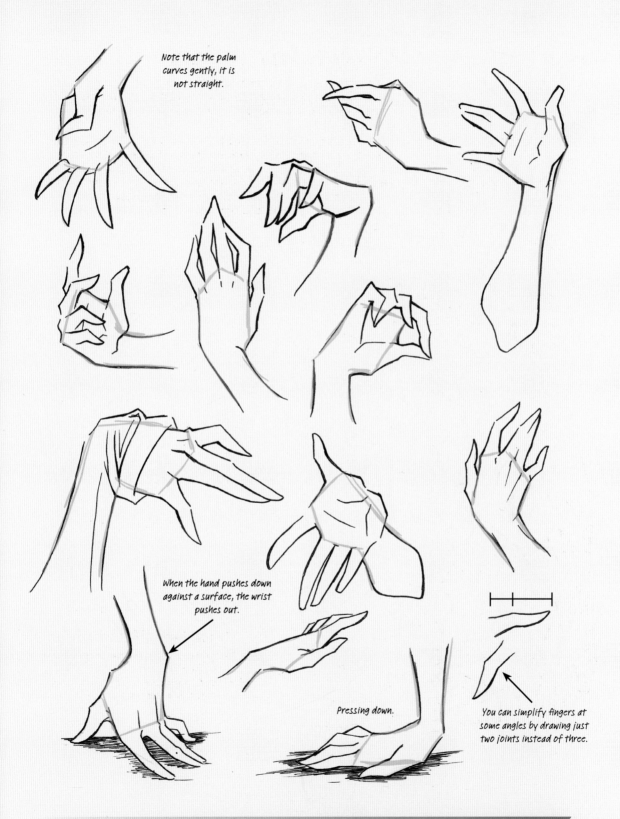

Note that the palm curves gently, it is not straight.

When the hand pushes down against a surface, the wrist pushes out.

Pressing down.

You can simplify fingers at some angles by drawing just two joints instead of three.

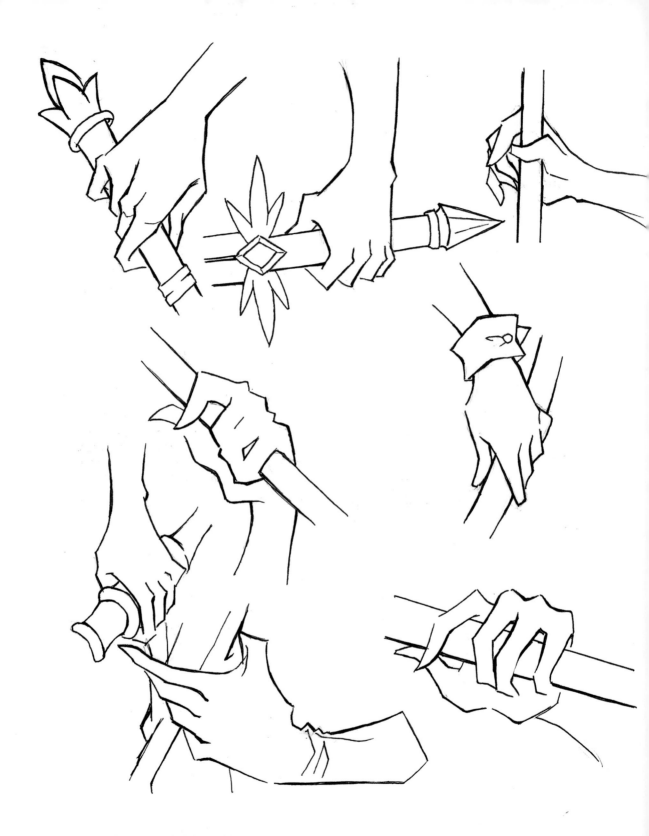

Taking hold

Grabbing and grasping objects is a very common action in manga art and it will increase the quality of your poses to have your characters interacting with their surroundings.

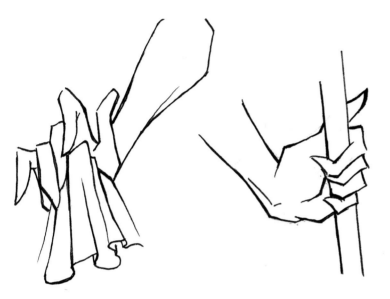

Objects don't have to be weapons – try putting different items in your figures' hands and see if that helps to show their character.

TOP TIP !

Take photographs of your own hands and use them as reference if you have a hard time with a particular pose that you want to draw.

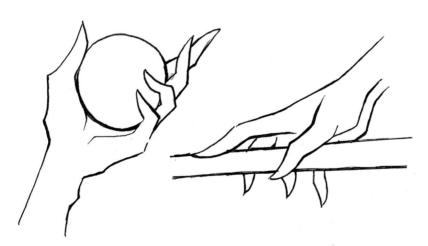

Arms

Something has to connect your figure's hand to their body! Like the information on the torso earlier (see pages 56–57), these illustrations show the muscles of the arm in detail – but again, you just need to concentrate on the basic surface shapes.

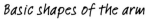

Basic shapes of the arm

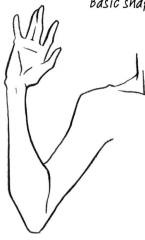

Most figures in manga are relatively clean-limbed and slender and do not need lots of distracting detail in their arms – just enough to suggest the shape.

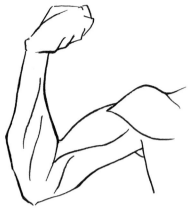

Muscular characters benefit from a little extra definition in the shapes and dips their muscles make.

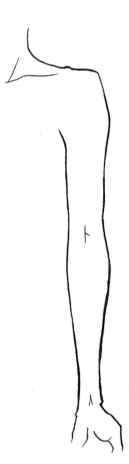

Arm joints

The wrist, elbow and shoulder are the main joints of the arm. A little detail on the elbow and wrist is all you need to detail the inside of the arm (see left), and the outside of the arm (see right) needs even less; a simple mark at the elbow will suffice.

Note how the arm interacts with the neck as it connects at the shoulder.

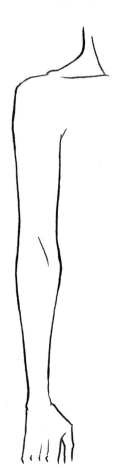

The arm in detail

Muscles of the arm

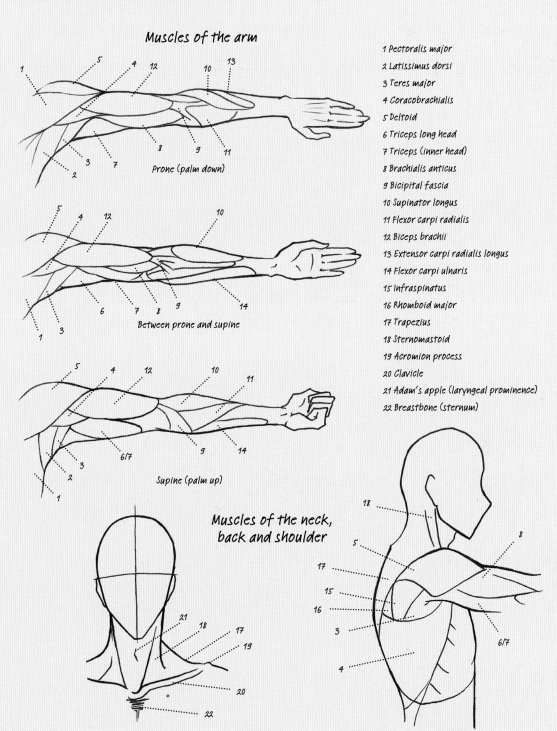

1 Pectoralis major
2 Latissimus dorsi
3 Teres major
4 Coracobrachialis
5 Deltoid
6 Triceps long head
7 Triceps (inner head)
8 Brachialis anticus
9 Bicipital fascia
10 Supinator longus
11 Flexor carpi radialis
12 Biceps brachii
13 Extensor carpi radialis longus
14 Flexor carpi ulnaris
15 Infraspinatus
16 Rhomboid major
17 Trapezius
18 Sternomastoid
19 Acromion process
20 Clavicle
21 Adam's apple (laryngeal prominence)
22 Breastbone (sternum)

Prone (palm down)

Between prone and supine

Supine (palm up)

Muscles of the neck, back and shoulder

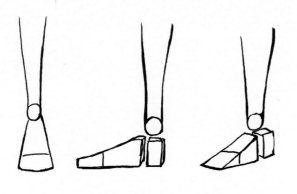

Feet

Just like the hand, the foot can be simplified and broken down into simple shapes to make it easier to understand and draw. In the case of the foot, these parts are shown to the left: a cylinder for the leg, ball for the ankle, block for the heel and a hinged wedge for the arch and toes.

The feet are created for balance and most of the weight is on the outer edge of the foot. Most of the time, you will only need to draw the basic form of the foot before adding shoes.

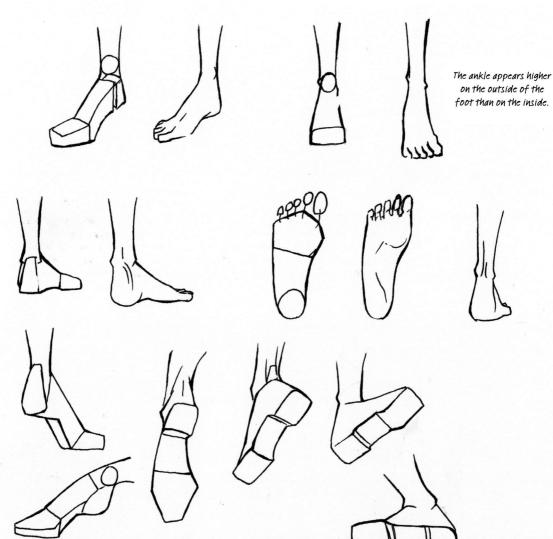

The ankle appears higher on the outside of the foot than on the inside.

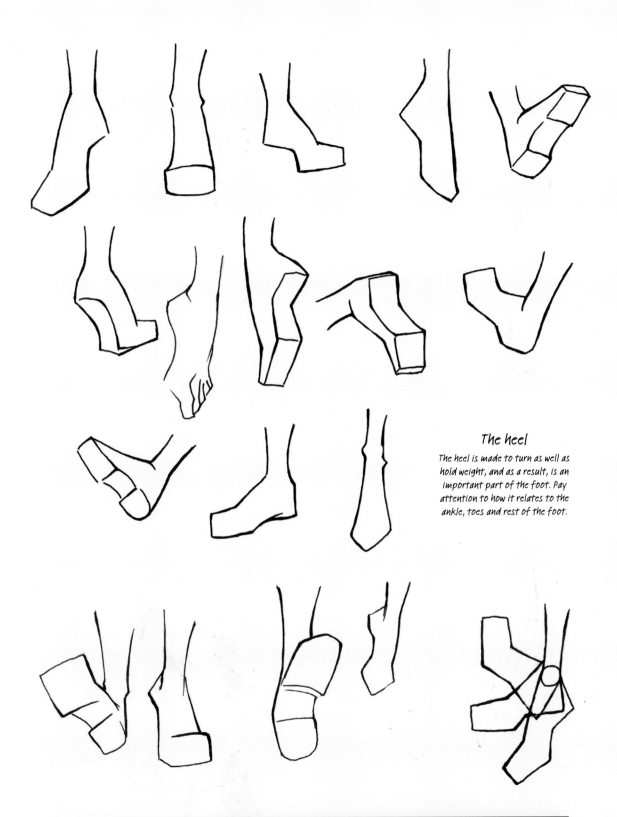

The heel

The heel is made to turn as well as hold weight, and as a result, is an important part of the foot. Pay attention to how it relates to the ankle, toes and rest of the foot.

Footwear

The trick to drawing shoes is to follow the same lines that are in the foot and include all the details.

The more details in your shoes, the better – this is especially true with lace-up shoes.

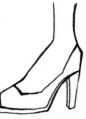

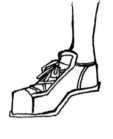 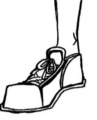 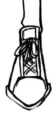

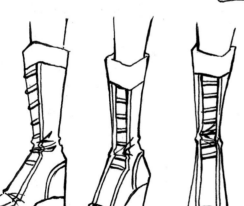

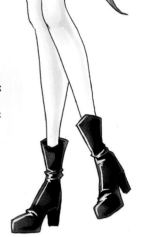

Typical shoes

On this page are examples of shoes from various angles of rotation. This helps to show how some typical styles of footwear look from different viewpoints.

More unusual footwear

Don't be afraid to get creative
with your designs!

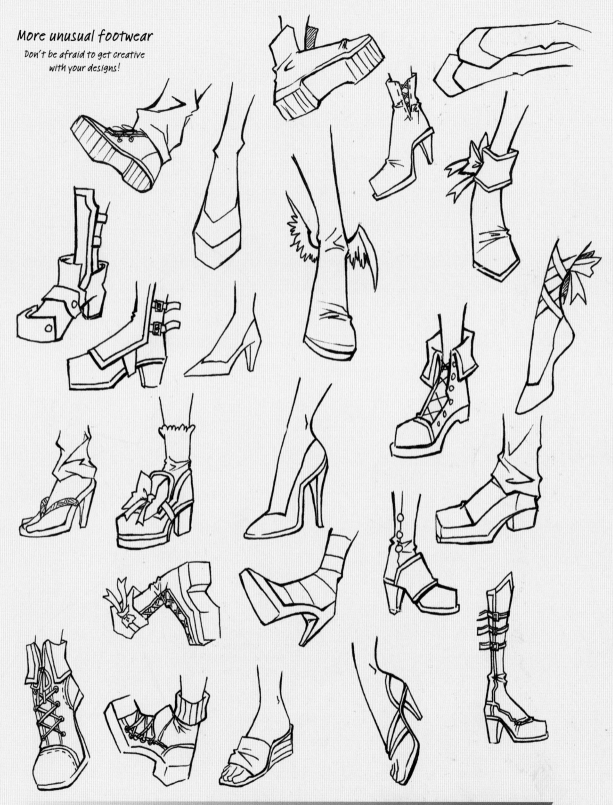

Legs

Men tend to have larger and more obvious muscles in their legs compared with women, who naturally have curvier legs owing to the shape of their hips. Fat deposits beneath the skin also obscure the surface muscle shapes a little.

Men's legs and buttocks are generally more square and angular due to this as well, so tailor how you accentuate the muscles of the rear to better define your characters.

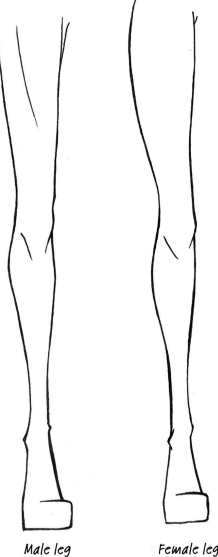

Male leg Female leg

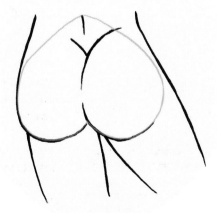

Male and female buttocks

Men's buttocks (top) form a rough heart shape, with the iliac crest forming the top of the upper part of the heart. Women's buttocks (below) make an upside-down heart shape, with the lower fat deposits forming the upper curve of the heart.

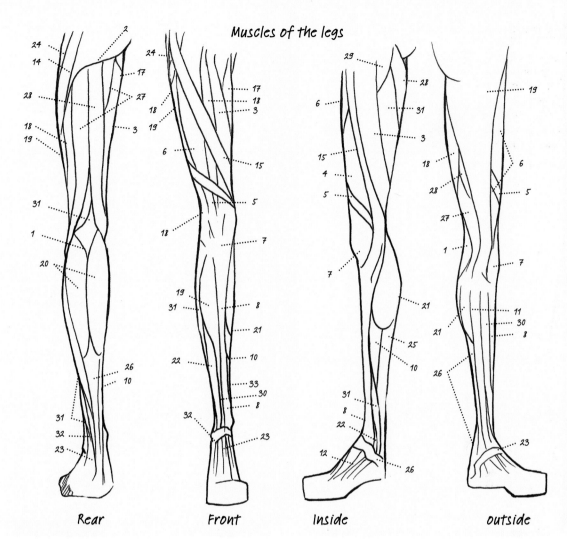

Muscles of the legs

Rear Front Inside Outside

The leg in detail

These diagrams show a simplified version of the muscles for manga artists, and knowing them will help you understand where to shade and how to draw the leg at different angles.

Taking the time to redraw and relabel these muscles will help familiarise you with the shapes.

1 Popliteal space
2 Gluteus maximus
3 Vastus internus
4 Vastus externus
5 Band of Richter
6 Rectus femoris
7 Kneecap (patella)
8 Tibia (subcutaneous surface)
9 Tibialis anticus
10 Soleus
11 Peroneus longus

12 Long extensor of the toes
13 Peroneus brevis
14 Tensor fasciae latae
15 Sartorius
16 Adductor longus
17 Gracilis
18 Vastus externus
19 Iliotibial band
20 Soleus
21 Gastrocnemius
22 Long extensor of the great toe

23 External malleolus
24 Gluteus medius
25 Tibialis posterior
26 Achilles tendon
27 Biceps cruris
28 Semitendinosus
29 Adductor magnus
30 Tibialis anticus
31 Semimembranosus
32 Long flexor of the toes

Pose

When posing your figures, keep in mind how your characters are supporting their weight. For static poses, the figure should be balanced. The figure below left is leaning his weight on his right leg (the leg on the left-hand side from our point of view), while the central figure is balanced on one foot. Her arms are held out to help her balance.

For dynamic poses, like the jumping figure below right, you need to introduce imbalance. The character should look like they will fall over unless they keep moving – it is this imbalance that suggests movement.

Masculine and feminine poses

If you want your character to appear particularly masculine or feminine without sacrificing character design, use the way you pose your characters. For example, men tend to turn their whole body and chest towards the person they are talking to, while women do not.

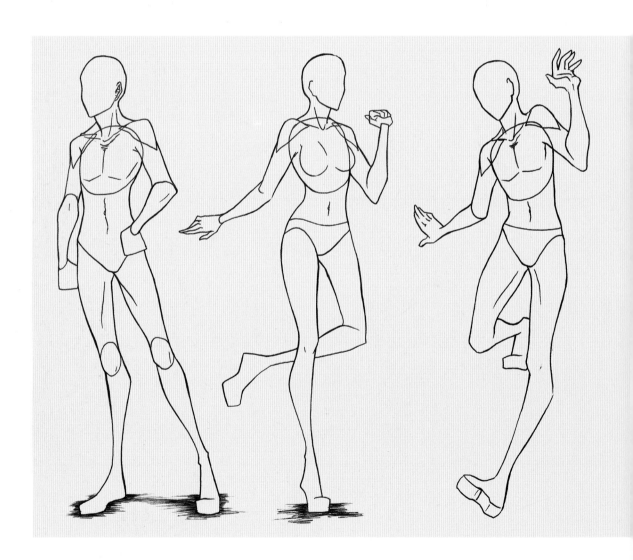

Using the torso and head for posing

The core body (torso and head) is important because it usually determines the centre of gravity for your figure. However the arms and legs of your figure are positioned, it is the positioning of the torso that will make your artwork successful.

To achieve a realistic result, the torso should be balanced. This does not mean your figure has to look rigid. You can add interest to the pose by putting the figure's weight on one foot more than the other. This will add a tilt to the hips. This tilt should be countered by tilting the shoulders in the opposite direction, which is illustrated in the examples below. Here you can see how making the tilt of the shoulders opposite to the tilt in the hips helps to create visual balance and interest.

Centre of gravity

Contrapposto is an artistic term that means 'counterpose', and it will help you get the centre of gravity right.

Contrapposto describes a figure standing with its weight on one foot, so that its shoulders and arms twist off-axis from the hips and legs. This creates a sense of weight to the figure and helps it to look realistic.

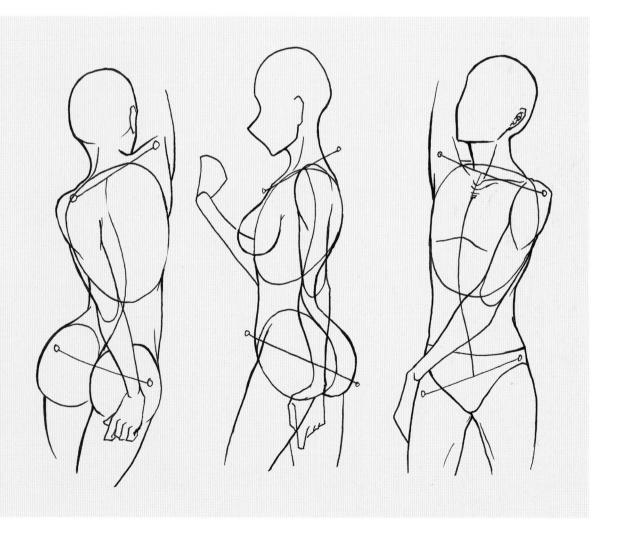

Age and pose

The proportions of figures change as they grow older. The head stays roughly the same size as the limbs and torso get longer and thicker and the hips and shoulders broaden. This causes the figure to get taller and appear older.

In general, attitude and age reflect each other. Children tend to be more energetic than adults, and this is especially true in manga art. Think of this when you are posing your characters and creating personalities and outfits for them. This will help your characters be more believable and realistic. Use your character's body language to your advantage to make them seem more realistic and to convey their personality.

For this older example, I wanted him to grow into a bratty pre-teen. I used his pose and expression to show this change in attitude.

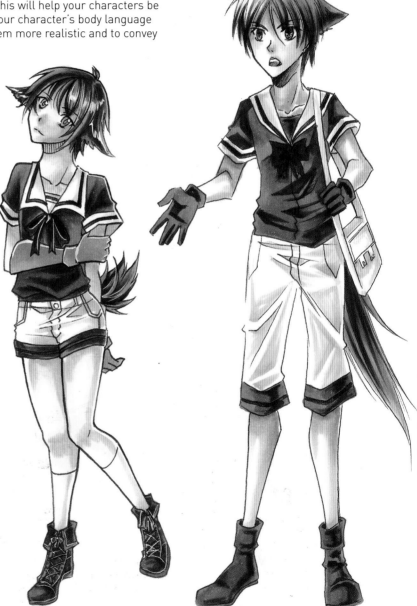

This version of the character is a young child. His pose is unthreatening and cute, to show sweetness.

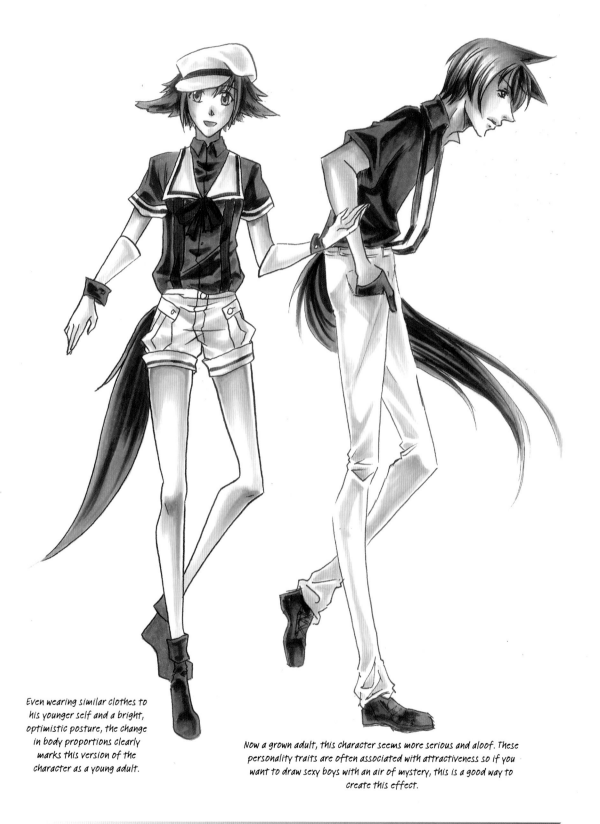

Even wearing similar clothes to his younger self and a bright, optimistic posture, the change in body proportions clearly marks this version of the character as a young adult.

Now a grown adult, this character seems more serious and aloof. These personality traits are often associated with attractiveness so if you want to draw sexy boys with an air of mystery, this is a good way to create this effect.

1 Draw the chest cavity/ribcage area.

2 Draw in the hips and connect them to the torso, making the tilt of the hips counter the tilt of the shoulders.

3 Now add the head and neck, using the torso as a guide to height. Together, the neck and head combined should be the same height as the torso area.

Drawing a basic figure

Following this step-by-step walkthrough will allow you to draw a simple figure. A common mistake when drawing figures is not being sure of the pose you want to draw and changing halfway through. Decide on the pose you want to draw before you start, and keep it firmly in mind as you work.

As mentioned earlier, we start by drawing the torso, then adding on the head and limbs. This allows you to compare the size of the head and neck to the torso to make sure the proportions are correct. Before you add the limbs, check that the core body has a balanced centre of gravity.

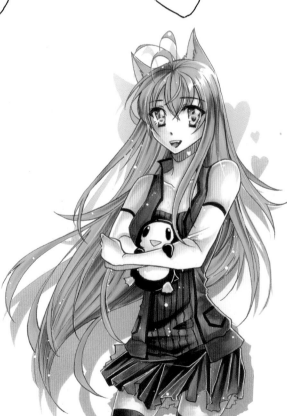

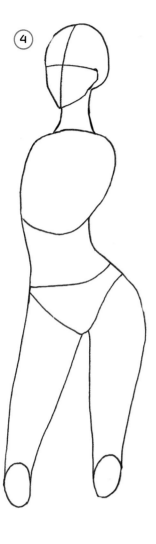

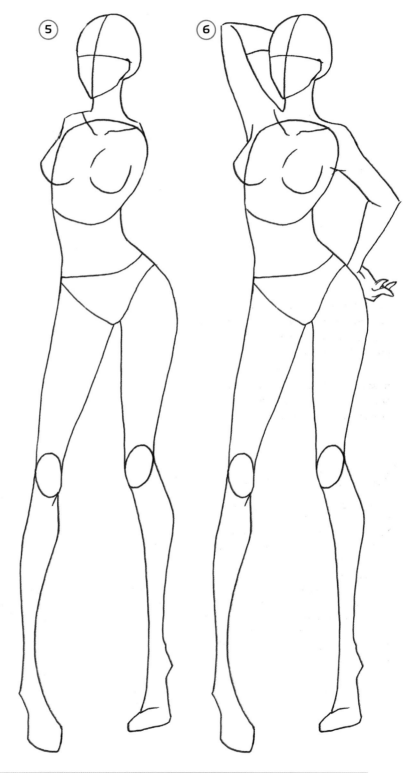

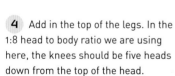

4 Add in the top of the legs. In the 1:8 head to body ratio we are using here, the knees should be five heads down from the top of the head.

5 Draw the bottom half of the legs and develop the chest.

6 Draw in the arms and the basic figure is complete!

Kemonomimi: animal features

The Japanese term for humanoid characters with features of an animal is *kemonomimi*, which literally means 'animal ears'. Animal features add a cute and adorable element to anime and manga.

There are many different ways to combine animal features with your figures to draw great characters. The animal type you choose can inform the personality – a character with dog features might be loyal; or simply slightly dopey!

Ears

Ears can simply be integrated into the hair of a figure, as shown below. Look carefully at photographs of real animals to help you with the placement of the ears. Fox or rabbit ears, for example, sit on top of the head, while lamb or dog ears might sit further down the sides.

Fox or wolf

Dog

Squirrel

Rabbit

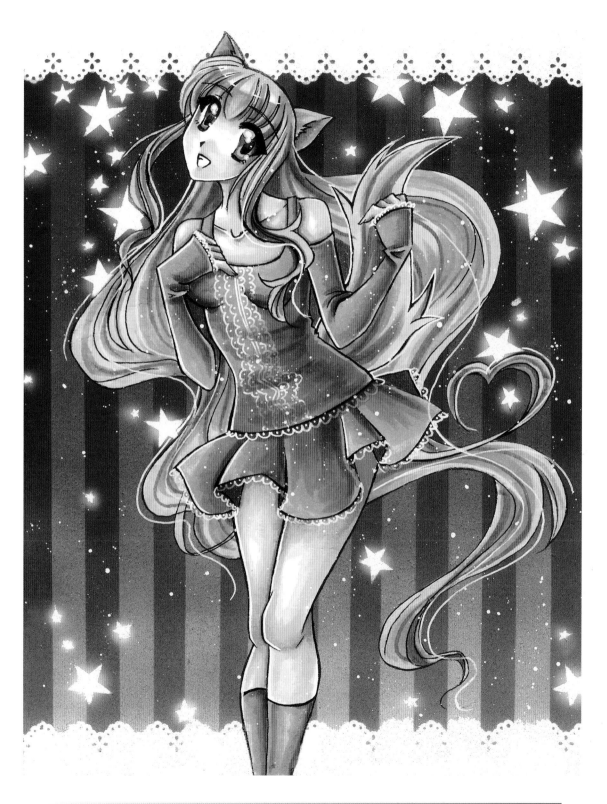

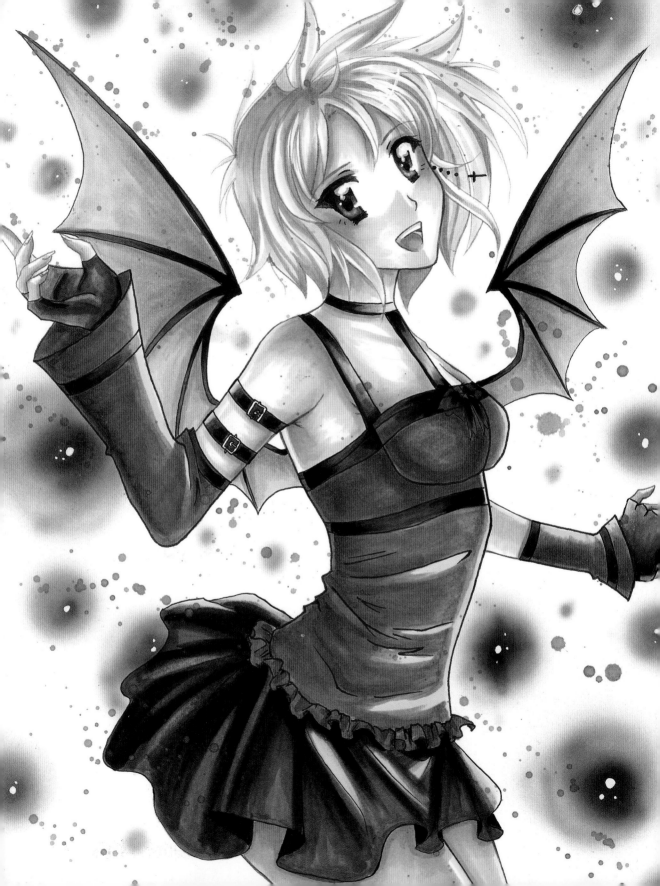

Wings

Wings are another animal feature that you can add to your characters. Bird wings are a great source of inspiration for angelic pinions, but bat wings (which will give a devilish look) or even insect wings can be used.

Wings and movement

Wings naturally bend and fold over and are in an almost constant state of motion.

When drawing wings, remember that the top half bends forward towards the character's front. As a result, if the figure is turned with their back to the viewer, the top of the wings leans away from the viewer and towards where the character is facing.

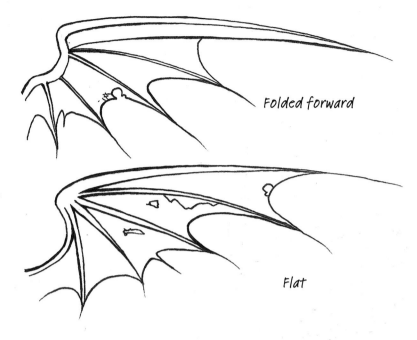

Folded forward

Flat

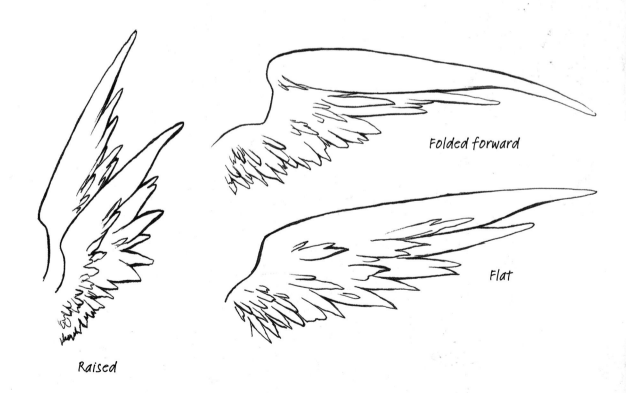

Raised

Folded forward

Flat

Wings and personality

Use wings to add definition to a character design and create interesting compositions (see pages 94–97 for more information on composition).

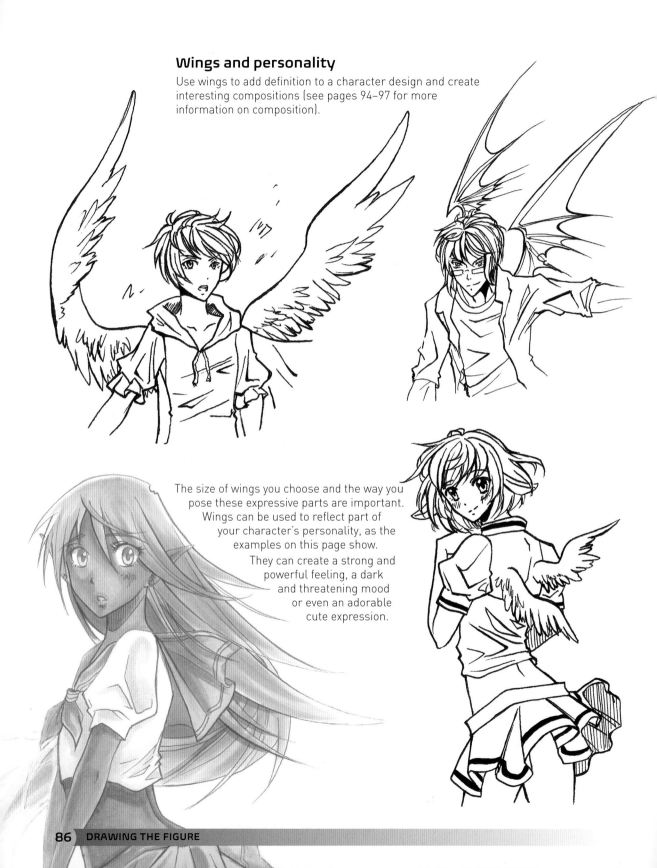

The size of wings you choose and the way you pose these expressive parts are important. Wings can be used to reflect part of your character's personality, as the examples on this page show.

They can create a strong and powerful feeling, a dark and threatening mood or even an adorable cute expression.

Tails

Just as with ears and wings, tail types can be mixed up based on what you want to say about your character, or simply to suit your style choices. Your character's tail can be thick and fluffy or long and elegant. Have fun and experiment!

More examples of tails

When drawing tails and ears feel free to combine features from different animals to create a sense of fantasy.

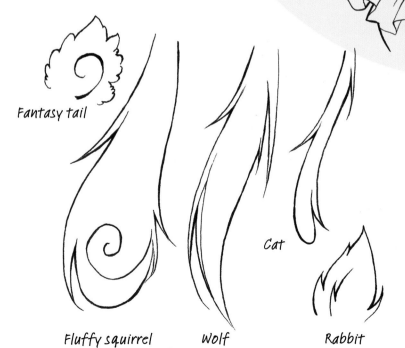

Fantasy tail

Fluffy squirrel

Wolf

Cat

Rabbit

Chibis

Chibis are miniature versions of anime characters with proportions that make them shorter and fatter than a standardly proportioned character. They are used to convey a 'cute' effect in manga and are very popular among fans and artists. Chibis' emotions and movements are often over-emphasised by the artist to create a humorous mood as well.

Chibi styles

The two most common types of chibis are a standard chibi, shown here on the right, and a super chibi, shown on the left. The proportions are slightly different, but note that in both styles the head is very large compared with the body. This is the main characteristic of a chibi character.

The super chibi style is historically more representative of this type of stylisation, but the slightly more realistic approach on the right is becoming more and more popular, particularly with younger anime fans.

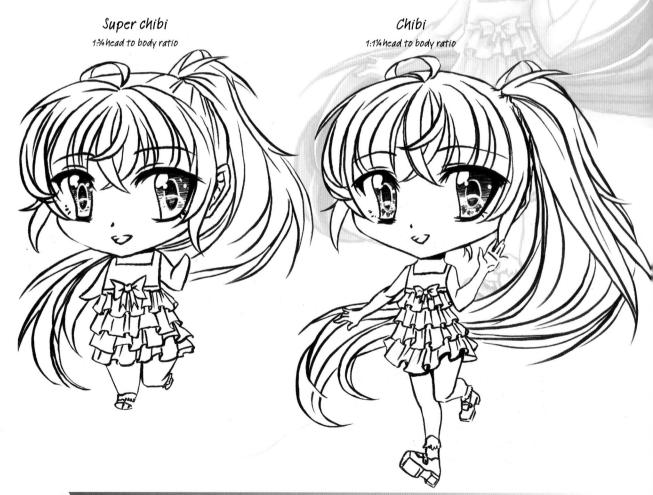

Super chibi
1:¾ head to body ratio

Chibi
1:1¼ head to body ratio

Drawing a super chibi

Super chibi figures tend to have bodies that are almost bean-shaped, and very simple arms and legs, with no distinct hands or feet.

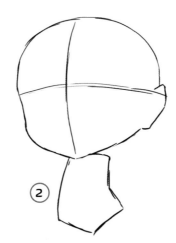

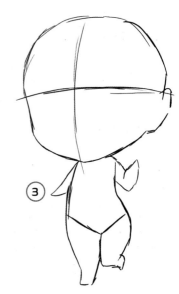

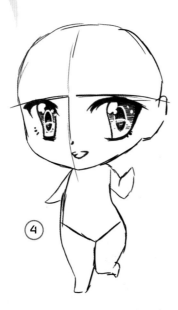

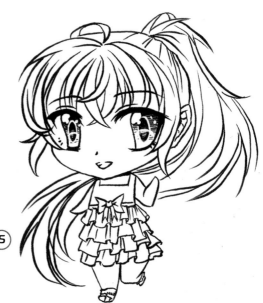

1 Just like a normal figure, we start by drawing the body. Make it straight on one side (the front) and bowed on the opposite side.

2 Draw the head, making it roughly twice the height of the body.

3 Add simple legs and arms, making the legs slightly shorter than the body to create the 1:¾ head to body ratio. Keep the feet or hands as simple paddles or 'flippers'.

4 Add in the facial features, using standard proportions for the face for placement, but exaggeratedly large eyes.

5 Add the hair and clothing to finish.

Other super chibi examples

The examples on these pages show more figures drawn in the super chibi style. In each case, the basic structure is shown on the left, and the more developed version – with facial features, clothing and hair in place – on the right.

Note that in the super chibi style, there is no difference in male and female anatomy. Clothing and accessories like wings or the broomstick in the example on the lower right of the opposite page should be drawn in scale with the body; while parts on the head like hair, hats or animal ears should be drawn in scale with the head.

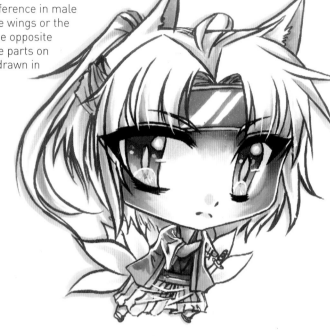

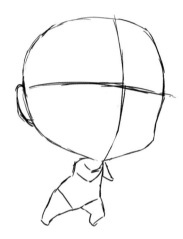

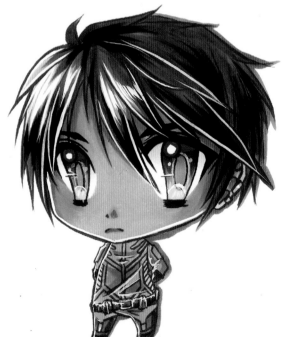

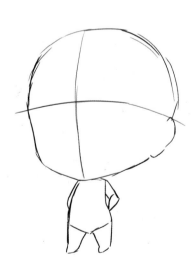

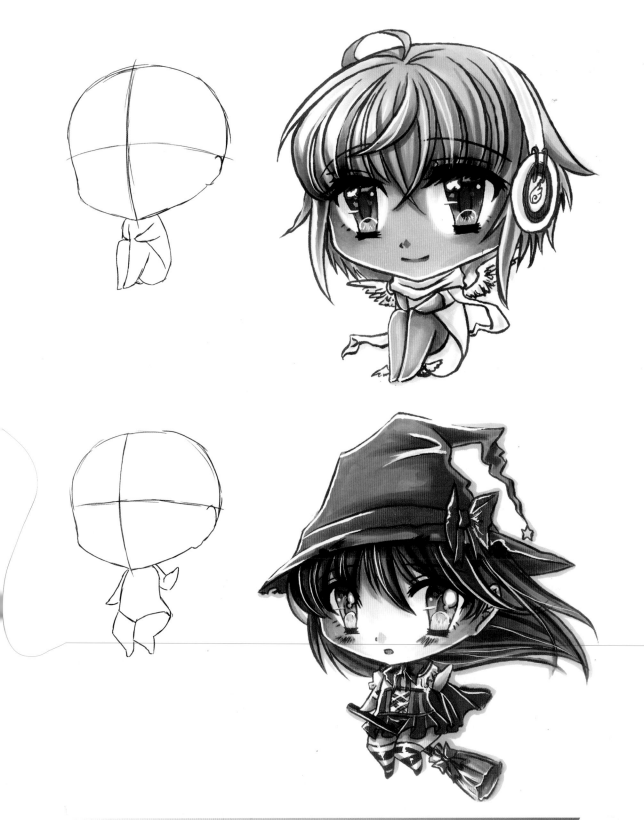

Drawing a chibi

This chibi is drawn in a similar way to the super chibi on page 89, but the proportions of the head and body are slightly different, and the hands and feet are properly developed.

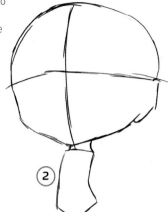

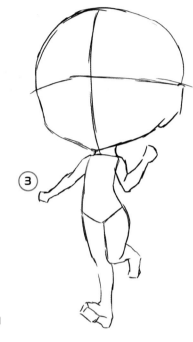

1 As with a super chibi, draw the body as a bean shape. For this slightly less exaggerated style, draw it slightly narrower than the super chibi body.

2 The body is slightly larger than half the head, so measure upwards and draw the head.

3 Add the arms and legs, making the legs slightly longer than the body to create the 1:1¼ head to body ratio. Unlike super chibis, the hands and feet should be fully drawn out, though aim to keep them in proportion with the limbs.

4 Draw in the facial features using standard proportions for placement, but exaggeratedly large eyes.

5 To finish, draw in the hair and clothing, then colour.

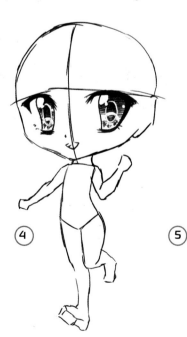

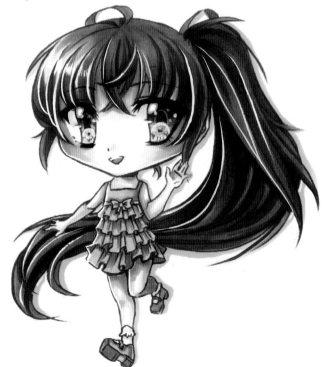

Other chibi examples

There are some differences between the male and female figure in chibis, unlike super chibis. However, these are very slight, essentially confined to the torso being slightly curvier in female chibis (see top example) and blockier in male chibis (see bottom).

Having longer limbs and torsos, chibis can be drawn in a greater range of poses, such as the more active female and relaxed male shown here.

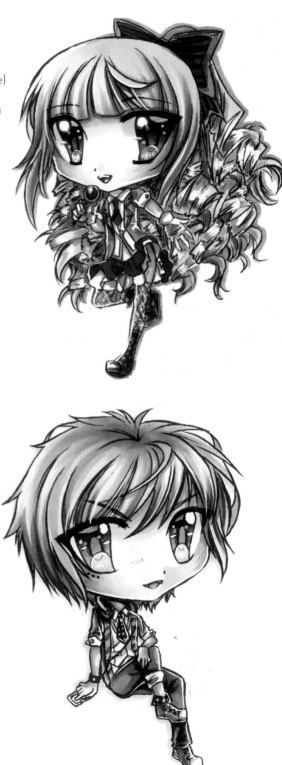

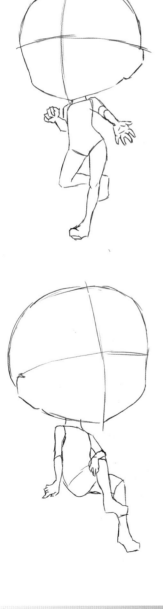

Composition

Composition describes the placement of the objects in a picture. These objects include the parts of the figure (head, body, etc.) as well as the background and any clothes or accessories they have. Placing these objects will allow you to make a lively, exciting picture by leading the viewer's eye around the image.

Simple compositions

These pages show a few common types of composition to give you some ideas and help you get started. I have added green lines to the artworks to show the path of the viewer's eye.

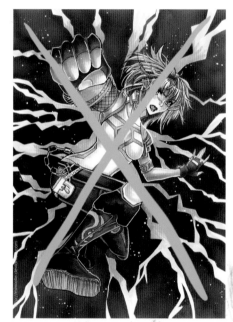

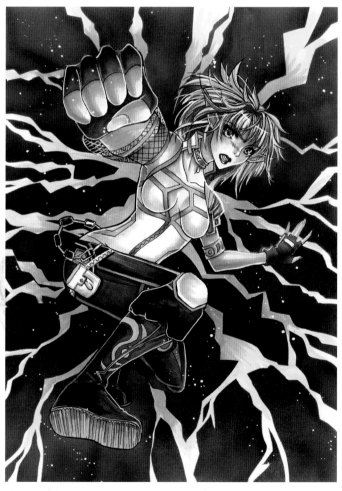

X-shaped composition

The elements of the picture form an 'X' shape, which draws attention towards the centre of the image. In this example, the torso is at the centre of the X, with the limbs and head leading in towards it.

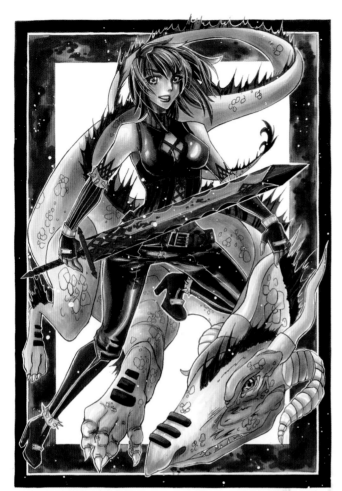

S-shaped composition

Shaped like an 'S', this composition will help to create motion and movement in your pictures to make them more dynamic. The sinuous dragon and the figure here both contribute to the overall S shape.

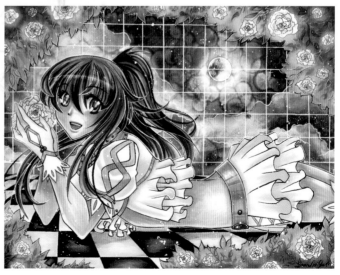

Pyramid composition

This type of composition focuses on one part of the image, like a character, and is usually in landscape format. Here, a triangle is formed with the head at the top point.

Other compositional tools

These pages show some ways of composing your pictures taken from traditional art. They break up the surface of the page into areas, which can help guide your placement of the compositional objects. They can help create fantastic and unusual compositions.

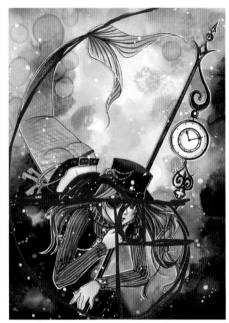

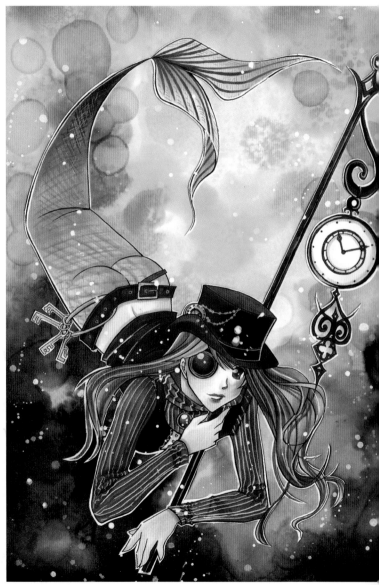

The divine spiral

The divine spiral, also called the golden ratio, is a common way of dividing up the layout and composition of an image and creating movement through the illustration. The divine spiral is based on how things form naturally in the world – as seen in the chambers of a nautilus or the spiral of a snail shell ~ and can be flipped and rotated. It can also be expressed mathematically.

To begin, break the image into a series of increasingly smaller squares as shown in red above. You can then draw a spiral from the inside using a pair of compasses.

The spiral draws the eyes around the image to the main focal point – the figure's face, in this example.

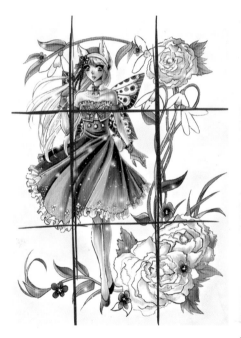

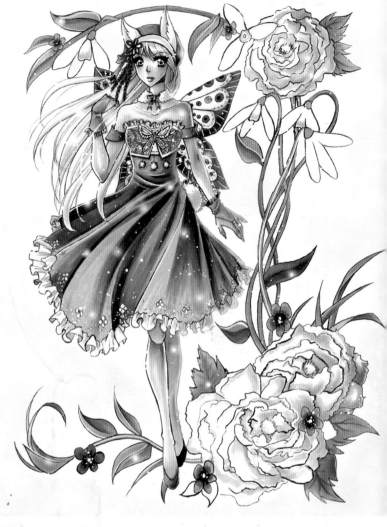

The rule of thirds

Using a grid to divide your image into nine rectangles, as shown above left, can be very helpful in placing your figures and other compositional objects.

Putting the strongest elements along the lines and cross-sections of the grid will prevent the finished picture from being overly symmetrical, and give good balance. In this example, the figure's head and one shoulder is near the intersection at the top left. This is balanced by the flowers in the lower right. Note that the flower stems follow the shape of the grid, framing the figure.

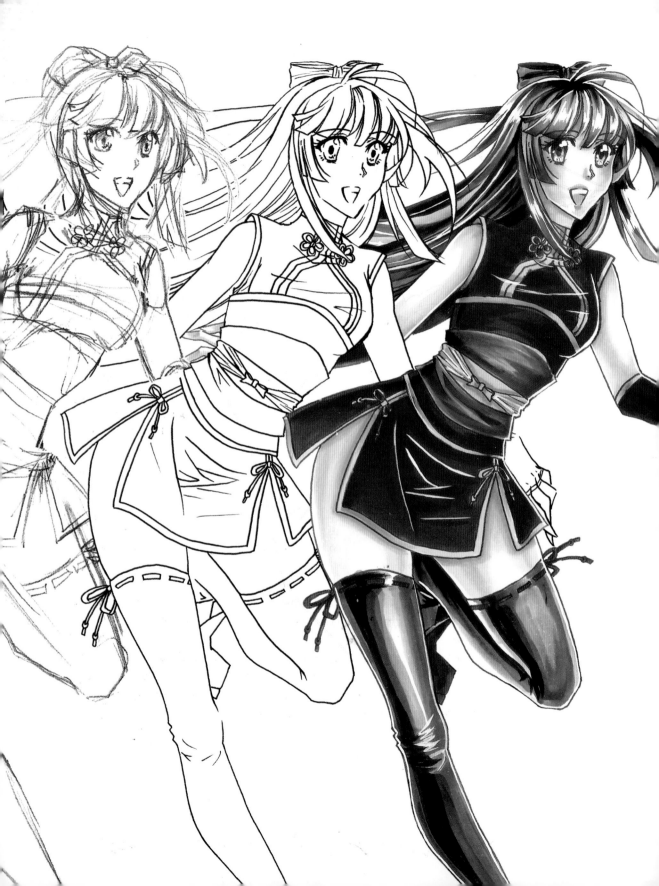

INKING AND COLOURING

Inking, also called lining, makes your work look more clean and crisp. It helps to define your lines, and using the right ink and pens will keep your lines from blurring when you colour over them. More than that, inking adds a professional quality to your work, which helps the viewer to lose themselves in the scene. When creating illustrations, the goal is ultimately to tell a story with your artwork. Colour and lighting are extremely important in manga because they help dictate the mood and set the location, which add to the sense of a story being told.

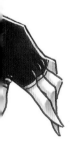

Always test your pens and ink with the colouring medium you intend to use on a separate sheet of paper before lining. This will prevent you from inking your whole picture only to realise that the ink runs when coloured with markers or watercolour, ruining the picture. I test my pens immediately after buying them and put tape on the ones compatible with my favourite media to mark them as suitable.

Move from your elbow or shoulder when inking, rather than moving the wrist. Try to keep a relaxed grip on the pen in your hand, too – if you hold it too tightly you can end up straining or hurting yourself. Aim to ink lines all in one go rather than repeated short strokes. This will give a smoother, more consistent result.

Inking can seem a little frustrating at first, but you will improve over time. Work slowly and stop immediately if you go off your line. Pick up your pen rather than trying to pull the line back. You can also rotate the paper to help you ink lines that are at harder angles for you.

Tools for inking

When inking, aim to create variation in the line weight. This means that your lines should not all be the same thickness. Having a variety of thick and thin lines creates a sense of life and movement for your characters and, by drawing attention to certain areas, helps them 'pop'.

Fineliners

You can get multiliners in many sizes and colours for a variety of line weights. Fineliners are also easy to find, easy to use and give the artist lots of options.

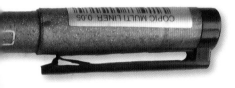

Copic multiliners

Copic multiliners Perfect for manga art, these pens are easy to find and have replaceable tips. The silver-cased pens are refillable, unlike the blue type. The nibs depress fairly easily, allowing for variation in line width.

Micron fineliner

Micron fineliners These are very easy to find and popular in Japan. The tips are hard and do not depress easily, which makes these pens give a consistent line width. This makes them good for beginners as well as excellent for panel outlines.

Prismacolor multiliners

Prismacolor multiliners I find that these pens do not handle pressure well, and fade when erased, but many American-style comic artists I know love them for their versatility.

Mitsubishi Uni pen

Mitsubishi Uni pens My absolute favourite pen for inking and character inking, these pens take pressure well and give a strong, even result.

Faber-Castell PITT pen

Faber-Castell PITT pens These pens have a decent tip, but I find the ink is very light compared with the others. As a result, the line fades quickly when erased.

Dip pens

Traditionally used for calligraphy and linework, dip pens do not have an ink supply like the fineliners opposite. Instead, you dip them in pots of ink. They are great for inking manga artwork, allowing great control over the line.

Dip pens come in two parts: body and nib. Not all bodies will fit all nibs, so check if possible before making a purchase. There are many types of nib available, and the choice can be overwhelming. The information below will help guide you in selecting which nibs you need.

Hunt 102 This is my favourite all-round inking pen. Very fine and flexible, it feels a little like a Maru (round) pen but bends like a G-pen (see below). This makes it able to produce a large range of line thicknesses with minimal effort

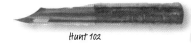

Hunt 102

Mapping nib

Drawing and mapping pens These are easy to find in shops, but I use them rarely, if ever, as I find the more specialised nibs described here fulfil all my inking needs.

Drawing nib

G-pen The most common type of nib used for drawing manga, this versatile nib is also the hardest to control because it responds very sensitively to pressure. Practice is key!

Zebra G-pen nib

School pens These will not bend easily, which makes them excellent for straight lines. For this reason, school pens are popular for background work.

Zebra school nib

Maru pen Maru pen nibs are round. Fine nibs like these are commonly used for hair and the tiny effects common in *shojo* manga (a type of manga aimed at younger girls).

Maru nib

Kabura pen Kabura pens have spoon-shaped nibs. They create good uniform lines that are neither as thick as the G-pen nor as fine as the Maru. Kabura pen nibs do not bend easily, which makes them good for inking if you have a heavy hand. Nikko makes good kabura nibs, as does Tachikawa. Tachikawa's kabura pen nibs have ridges towards the tip, which allow them to hold more ink.

Zebra kabura nib

Nikko kabura nib

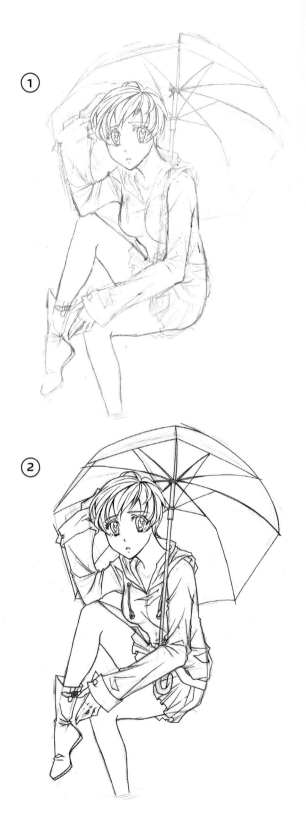

Inking a figure

You can use any fineliner for this but I used a Uni Pin 01, which has a fine 0.28mm nib. Sakura Micron and Prisma liners will work just as well, as will any others shown on the previous pages.

I prefer the 01 size because it is easy to work with and does not bend like a 05 will – the 05 has a finer 0.05mm nib – but for facial details it may be easier to use a finer nib.

1 Draw out your sketch with pencil, making any adjustments you wish before continuing. You do not need to erase all the excess pencil marks, but make sure you can see the main lines before you begin to add the ink.

2 Start to ink your lines simply. Move your hand slowly and ink from your shoulder or elbow rather than your wrist for lines longer than 1cm (½in). Try to ink whole lines in one stroke rather than many smaller strokes, and if you start to go off the line, stop immediately and redo the line. Do not worry too much about line weight, except for clothing folds and hair edges. For these, lift your hand slightly and apply less pressure towards the end of the stroke to create a sharp edge.

TOP TIP !

If you add colour outside the lines you can simply go over it with white-out or acrylic paint if you are not going to colour that spot again. If, however, you do intend to colour the area again, leave it in place and edit the line out digitally when you are done.

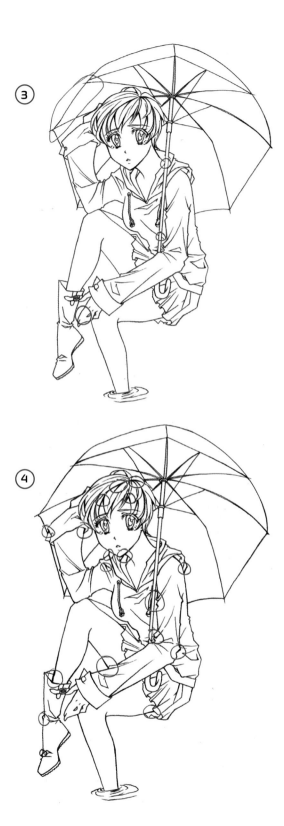

3 Once the ink is dry, rub away the pencil lines of your sketch with a plastic eraser, then use a white paint pen or a brush and white paint – I used a Molotow paint pen here (see page 116) – to get rid of mistakes. Circled here are the areas where I used white paint. Keep in mind you can not use certain colouring tools (such as coloured pencil or Copic markers) on top of white paint, so try to keep these corrections where there will not be colour in the finished image, or paint over it with acrylic paint while colouring.

4 To finish inking, go in and use the fineliner pen to increase the line thickness anywhere two lines meet. I have circled a few example places where I have done this, but you can see it is throughout the whole picture. Continue adding depth and correcting any mistakes that need it. Your inked figure is now ready for colouring.

Colour theory

You can make things look appear more magical and wonderful when you understand lighting, and your characters will look more believable when you know where to put shadows and highlights to create the mood you want. Understanding some of the qualities of colour and light will make your work a lot easier and more enjoyable.

To begin, let's start with a few very basic definitions about colour. Colours can be split into a few groups:

Primary colours Those hues that can not be mixed from other colours: red, yellow, blue.

Secondary colours The colours that can be mixed directly from primaries: orange (red and yellow), green (yellow and blue) and purple (blue and red).

Tertiary colours All colours that are not primary or secondary.

The colour wheel

A colour wheel is a way of arranging colours that shows the relationships between different hues. The colour wheel is incredibly important to reference when choosing your colour palette, as it allows you to see at a glance how the colours that you choose will complement, harmonise and contrast with each other.

To make a simple colour wheel, you add the three primaries in a circle, then add the mixes in between, as shown to the right.

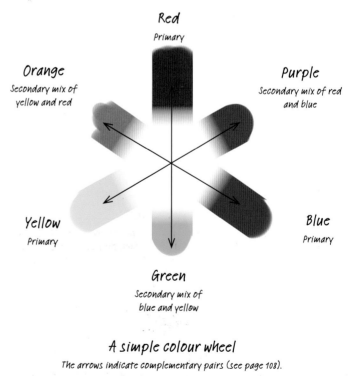

Red
Primary

Orange
Secondary mix of yellow and red

Purple
Secondary mix of red and blue

Yellow
Primary

Blue
Primary

Green
Secondary mix of blue and yellow

A simple colour wheel
The arrows indicate complementary pairs (see page 108).

Qualities of colour

The following terms are used to describe colour. It may seem quite technical, but if you are interested in why a particular combination of colours works, this information will be helpful.

Hue This refers to the colour itself – the blueness of blue, for example.

Saturation This refers to how much of the colour itself is present, or how much grey is present. I think of this as brightness or purity of a colour as well.

Value The relative amount of white or black in a colour.

Tint Adding white to a hue will lighten or tint it.

Shade Adding black to a hue will darken it, creating a shade.

Pure hues

A selection of pure hues.

Saturation

This blue hue is desaturated on the left – the hue is stripped out, leaving only the grey tone – and fully saturated on the right.

Tint and shade

This green hue is tinted to pure white on the left, and shaded to pure black on the right.

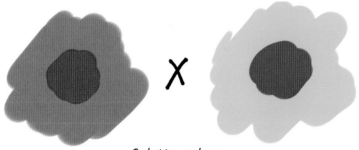

Relative colour

If you look directly at the X in the centre, you will see that the pink dot in the blue area appears darker than the pink dot in the orange area. In fact, the pink is the same hue in each case – but your eyes perceive the colour differently owing to the surrounding colour.

Colour perception

Colour is relative; our perception of it changes based on the other colours around it, and so the same colour can appear very different if used alongside different colours.

Furthermore, the same colour will look darker when surrounded with light-toned colours and lighter with dark-toned colours.

Relative tone

The grey line in the centre is all the same colour, but appears to vary in tone owing to the surrounding tone.

Colour temperature

Colours are said to have a temperature. Cool and unsaturated colours evoke calmer and mysterious emotions, while warm saturated colours create more excitement.

Generally speaking reds and oranges are warm while blues and greens are cool, but there are many exceptions. Cadmium red, for example, is a warm red paint, while alizarin crimson is a cool red paint. Temperature is also relative. The green labelled A in the diagram to the right seems cool compared with the reds to its left, but warm compared with the blues immediately to its right.

You might choose to use only cool or warm colours in your artwork to evoke a particular feeling, or combine them for additional effect. A warm element in a composition will jump out at the viewer if the rest of the artwork uses cool colours.

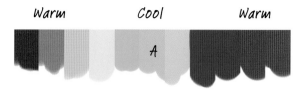

Relative temperature

As with tone and hue, colour temperature is relative and a colour will appear warmer or cooler based on the colours that are next to them.

Cool palette

The cool blues, violets and purples used in this artwork give an ethereal, dreamlike quality to the composition.

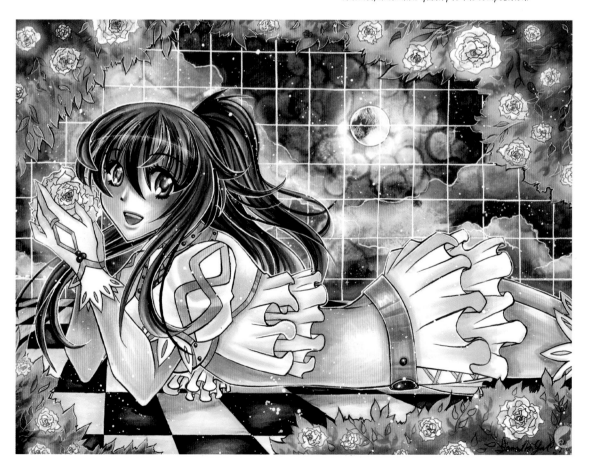

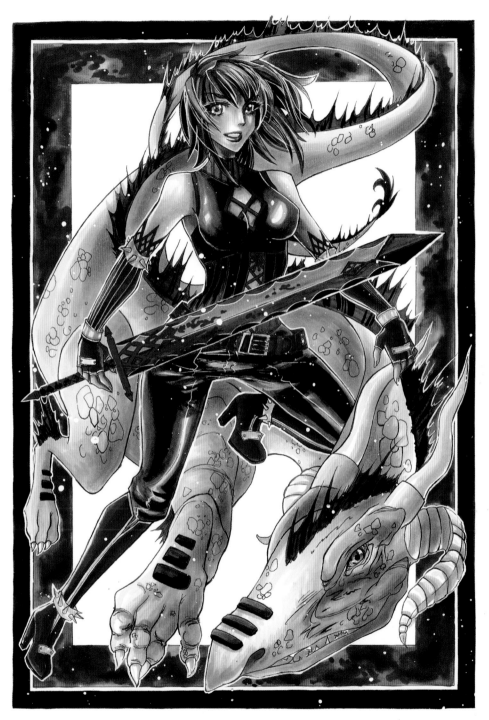

Warm palette

The hot reds and oranges in this composition give it an exciting, eye-catching and dynamic feeling. Note how the cool green eyes of the figure and dragon jump out in contrast.

Picking a colour scheme

Picking a colour scheme is important to creating a mood or evoking an emotion. The colour wheel can be used to help you choose colours that will work well together. Some of these relationships are explained below.

Complementary colours These are pairs of colours that sit opposite each other on the wheel, as indicated by the arrows on the colour wheel on page 104. Red and green, for example, are complementary colours. Complementary colours ground and balance each other when used in the same image, and always look good next to each other. For this reason, using a pair of complementary colours is an easy place to start when deciding on what colour scheme to use for your artwork.

Split complementary A split complementary scheme is made up of one main colour plus the two adjacent to its complementary. If red is your main colour for example, the split complementary colours will be the two that sit next to green, red's complementary colour – i.e. yellow and blue.

Analogous colours A series of three to five colours that sit next to each other on the colour wheel. Yellow, green and blue are analogous, for example.

Neutral colours In a colour scheme the neutral colours are the browns and greys created by mixing and combining colours. These colours allow you to keep your colour scheme interesting while creating shadows.

Monochrome Often thought to be simply black and white, this actually refers to all the tints and shades of a single colour, up to and including pure white and pure black.

Test your colours

The exact colour you use will affect its complementary. There are lots of different blues for example; some that err towards purple, others that err towards green. As long as you take this into account when picking the complementary and remember that it is always directly opposite on the colour wheel, you will be able to find the right colour to complement the one you pick.

If your blue is a bit more purple, the complementary orange should be more yellow, if your green is a bit more blue, your red should be more orange, and so forth.

Split complementary colour scheme

This is an example of a split complementary colour scheme. The figure's orange-red hair provided the first colour, which is complemented by the warm yellow-tinged green and cool blue-green of her clothes. Compare and contrast this scheme with the alternative palettes on the opposite page to see how important a colour scheme is to creating impact.

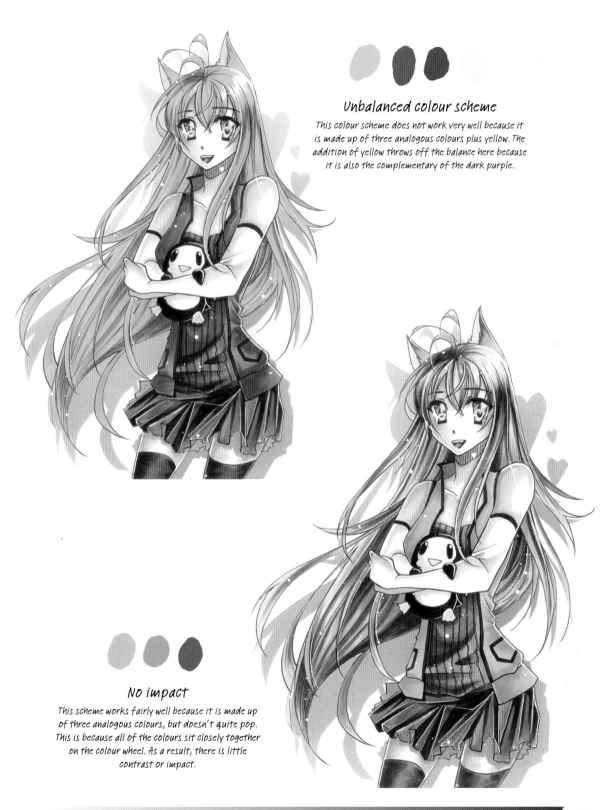

Unbalanced colour scheme

This colour scheme does not work very well because it is made up of three analogous colours plus yellow. The addition of yellow throws off the balance here because it is also the complementary of the dark purple.

No impact

This scheme works fairly well because it is made up of three analogous colours, but doesn't quite pop. This is because all of the colours sit closely together on the colour wheel. As a result, there is little contrast or impact.

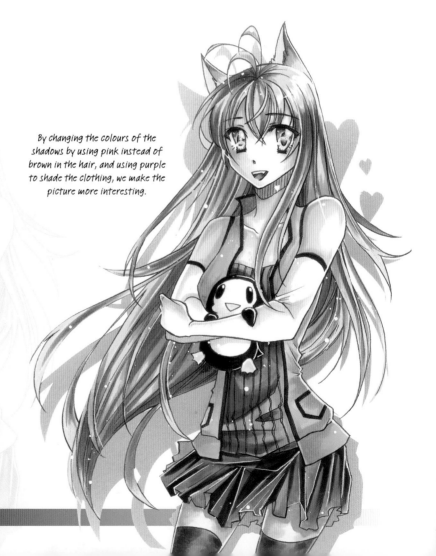

Improving a colour scheme

Of course, sometimes you may have to make a colour scheme work. Taking the example of the low impact scheme on the previous page as an example, the character's hair is yellow, so we can't change that. However, do you see how the hair here is coloured with darker browns? The rest of the clothes are similarly shaded with darker colours of the base colour – the green and blue clothes are simply shaded with darker greens and blue.

As we saw earlier, this use of analogous colour creates a muted effect. To improve the impact, we can play with the colours used in each part of the figure by using the complementary colour of each part for shading – pink shading in the yellow hair, and purple shading for the green and blue clothing. This is because these colours balance the colour scheme and create more interesting contrasts.

This is where colour relativity comes into play, and this is the reason why you should not just shade with darker colours of the base colour. If you want to keep a particular colour scheme, add interest within each element through use of complementary colours.

The original choice of colours for the shadows.

By changing the colours of the shadows by using pink instead of brown in the hair, and using purple to shade the clothing, we make the picture more interesting.

Colour and emotion

You can use colours in your artwork to emphasise your character's emotions – hot reds for extroverted emotions like anger or desire, and cool blues for inward-looking emotions like sorrow.

Red hues emphasise the character's anger.

Note how the blue hues here emphasise sadness.

Character and colour

Purple shadows in the skin tone were used here to suggest a darker character as in the example below left. Using pink as the shadow colours will create a lighter, more innocent look (below right).

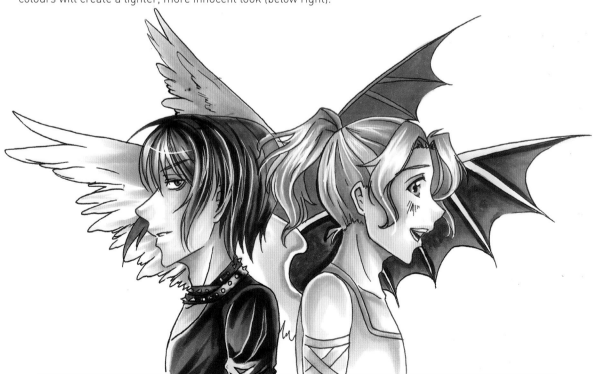

Light and shade

Knowing the basics of lighting theory will help to make sure you understand all the things to think about when colouring to give great results to your finished artwork. To keep things simple, I have drawn a ball below to demonstrate these basic principles.

Primary light source Your main source of light in the picture: where the light is coming from. In most pictures, this tends to be also the strongest light source.

Shadow The darkness on an object created by the lack of light or obscured light.

Cast shadow Shadows created by light being obscured or blocked by another object. Cast shadows have hard edges.

Reflected light The light that appears on an object that bounces off other nearby objects, rather than from a light source.

Secondary light source This is a secondary and smaller source of light. It is often created by a glowing object, or by particularly strong reflected light.

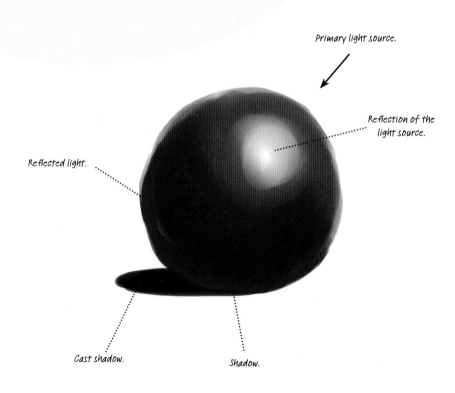

Primary light source.

Reflection of the light source.

Reflected light.

Cast shadow.

Shadow.

Lighting and surroundings

Of course, no object is completely isolated, so you have to take the environment and surroundings into account with your lighting. This can make some important changes to the object you are lighting. Hold your hand near to a coloured surface and your hand will pick up some of that colour as the light reflects from it, for example.

In the examples on this page, the same ball shown opposite has been put in a green room. Note how the reflected light picks up a green tinge from the walls in both versions.

In the lower example, note how the bright reflections on the left constitute a secondary light source of their own.

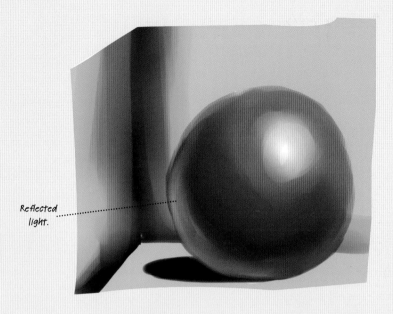

Reflected light.

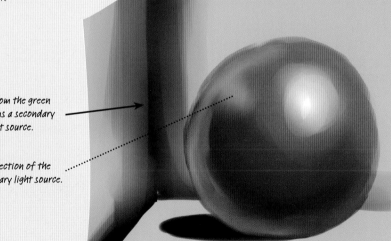

Light from the green wall forms a secondary light source.

Reflection of the secondary light source.

Light and shade in manga

The examples below show soft and hard cel shading, two styles of shading that we use in combination to achieve the distinctive manga look. How do the basics of lighting theory apply to manga artwork? The simple answer is that the lighting affects the type of shading you should use in your shadows when colouring. By using soft and hard cel shading in combination, as in the example at the bottom of the page, we can create texture and definition in our figures – and our artwork in general.

CEL SHADING
The term 'cel shading' comes from celluloid, clear sheets of which were used for traditional animation.

Soft cel shading
This type of shading has no hard edges, only smooth gradients.

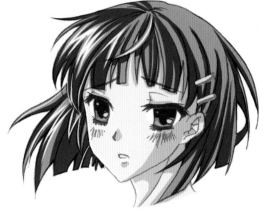

Hard cel shading
In contrast to soft shading, this has only hard edges and no smooth gradients.

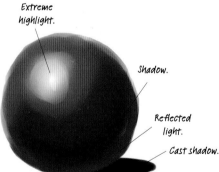

Extreme highlight.

Shadow.

Reflected light.

Cast shadow.

Light and shade on the head
The head may seem a complex shape, but the principles are exactly the same as in the ball we used earlier.

Look for the primary light source, and work out from there when colouring the head. You will get multiple shadows cast by the hair, nose, lips and jaw, but if you work gradually, you will soon find lighting becomes second nature.

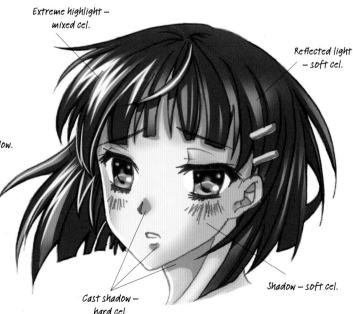

Extreme highlight – mixed cel.

Reflected light – soft cel.

Cast shadow – hard cel.

Shadow – soft cel.

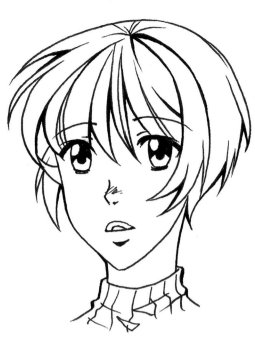

Where to place shadows

I am often asked where to place the shadows on an object. The simple answer is opposite the light source. Shadows are created when something blocks the light, or as light slowly dissipates around a curving area.

The examples on this page show where shadows fall on the same face when the light source is moved.

TOP TIP !

Strong light creates hard shadows, while soft shadows are created from reflected light, or from distant or secondary sources of light.

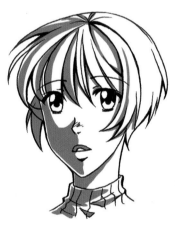
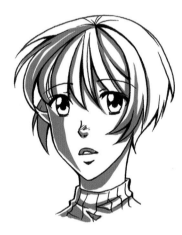
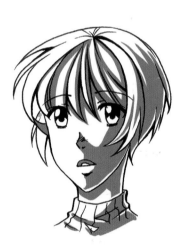

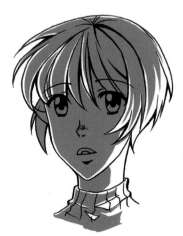
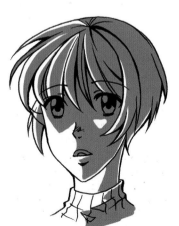

Extreme highlights

Highlights created using pure white are common in anime and manga. They create shine and contrast with shadows.

In the example to the right, the highlights were made by applying acrylic paint with a *menso fude*, a small bamboo brush.

You can also use a watered-down version of the paint for a softer highlight effect, or a different colour of paint entirely to add a highlight with hue.

Compare the impact of the original (left) with the completed, highlighted figure on the right.

Tools for highlights

Misnon (1) Japanese correction fluid. This is great for correcting mistakes when inking.

Dr. Martin's Pen-White (2) Another type of correction fluid, this is my favourite one which I use almost all of the time. It is easy to find, flows well and doesn't dry out too quickly.

Copic Opaque White (3) An easy-to-use white paint, this is thick enough to cover well and can be diluted. However, it is expensive and dries quickly, which makes it a little harder to use.

Pentel Sunburst white Gel pen (4) This pen produces a strong and solid white line which works well for striking highlights. Easy to find but runs out quickly.

Uni-ball Signo white pen (5) My favourite type of pen for highlights, this dispenses a thick line and seems to last forever!

Molotow white paint pen (6) Good for large mistakes, but because the lines it produces are thick, it is rarely suitable for highlighting.

Using shadows to create depth

Highlights draw the eye to parts of the figure, but shadows create the contrast that gives your artwork impact. Parts of the picture that are further in the background, like the character's hair, leg and arm, will be lighter in colour and less saturated. This means that they will have less colour to the and appear lighter.

1 To begin, draw and colour your figure as normal.

TOP TIP !

If you are working digitally, you can create a new layer specifically for shadows. If you are working traditionally, you can simply work directly over the previous colours.

2 Colour areas further back in the image, such as the hair behind the neck and the rear arm and leg with a light greyish-purple or grey-blue. These cool hues will push the areas back and make them look farther away.

3 Using watered-down white acrylic paint (or a new layer on reduced opacity in your graphics program), colour over parts of these same areas to soften the shape. More distant areas should be further back to add details and definition, so do not add flat layers; instead create gradients.

Coloured markers

Markers are my favourite medium with which to work. They allow both hard and soft shading very easily and, once mastered, allow you to work at great speed, with little to no drying time or clean-up. Marker pens also provide wonderful saturation and colour depth, resulting in clean, vibrant results.

The Copic range is popular for manga artists and is my particular favourite because of the variety available and the subtle variations in hue. If you choose another range, look for one that produces clean marks and is available in a wide array of hues to give you access to every colour you will need. Another valuable quality to look out for in the range of markers you choose is whether they are refillable or not.

The downside to a wide range of colours is that building up a collection of markers can be very expensive – I have around three hundred and the cost quickly adds up. If you are looking to get started with markers, I suggest buying a few at a time and gradually building a collection while you experiment. That way you save your money if you decide that you would prefer to use another medium, and you can also pick the specific colours that you need, rather than paying for colours you don't use in the large sets. When the ink runs out from one of your markers, buy a refill rather than another marker – it will save you lots of money to do this.

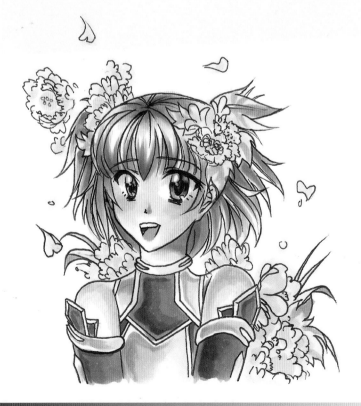

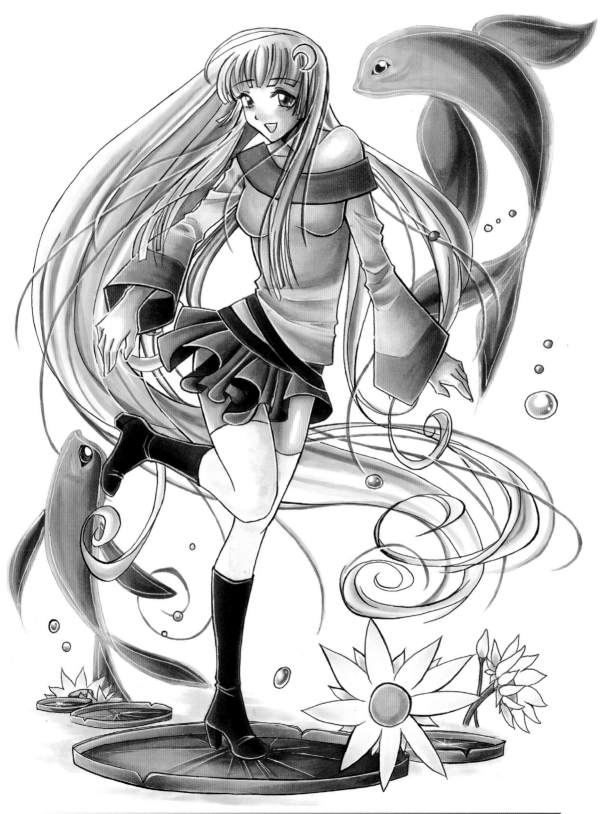

Refills
Copic markers refills are
called 'Various Inks'.

Copic markers

Types of coloured markers

There are many markers on the market for illustration. Letraset, Shin Han and Marvy Uchida, among others, produce excellent quality markers for your manga artwork. I tend to use Copic markers, which are well-known for their blending abilty. These are the ones most professional artists use. Copic produce four ranges of markers, of which two (Sketch and Ciao) have brush tips. All Copic markers are refillable and the tips are interchangeable and replaceable as well.

I recommend the Copic Ciao and Copic Sketch ranges. The main difference between the two is that the Ciao range is slightly smaller and more affordable, but comes in fewer colours. If you have never used markers, I recommend starting with a few from the Ciao range. The smaller range is less intimidating and easier to work out than the fuller Sketch range.

Multiliners and ink

The ink in markers can make some multiliner and outline inks run, so always test your pens and ink with your markers before starting your picture.

Some markers, such as the examples shown here, use water-resistant ink. This allows you to pass over the lines with markers without the ink bleeding. Luckily, they are also some of the easiest pens to find.

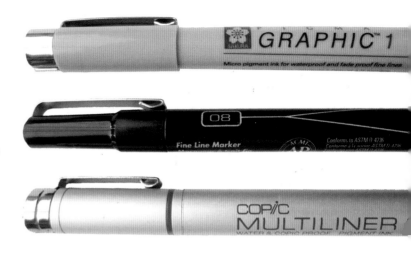

Multiliner pens

Pictured here are a Sakura micron, Prismacolor liner and Copic multiliner SP. The SP indicates the pen is refillable and the tip can be replaced when it gets worn down. All these pens have water-resistant ink.

TOP TIP !

Many inkjet printers also use water-resistant ink. Check if your printer does, as this will allow you to colour on print-outs.

Surfaces for coloured markers

Any paper or card with a smooth, non-textured surface should work well with markers. There are many papers designed with markers in mind on the market that are worth a try, so experiment and find the surface that suits you best.

My favourite papers are Maxon manga manuscript paper because it is easy to blend upon, and not too thick. I also like Borden & Riley #234 paper, which is smooth and hard, perfect for clean lines, and Bristol board, a smooth, thick cardboard intended for illustration. Bristol board is slightly absorbent, which means it will take more ink to blend because it will soak into the surface a little. As a result, it is easier to blend upon than thin paper.

Coloured marker techniques

Markers are very versatile tools and perfect for illustration work and the manga style owing to their vibrancy and clean colours. Practise the techniques on these pages to help you learn to make the best of this medium in your illustrations.

Feather blending with markers

1 Draw out a simple shape in pencil or pen. Using your first colour (BG23 in this example), fill in the top of the shape, then flick the brush tip downwards towards the middle to apply less colour there, as shown.

2 Use a second colour (RV32 is used here) to do the same thing in the opposite direction, working up from the bottom of the shape. Make sure the areas of colour overlap in the middle.

3 Colour over again with your first colour, working back and forth between the two colours as much as necessary until the colours blend in the centre. This is easier with colours closer on the colour wheel or lighter in tone than those far apart on the wheel or darker hues.

Layered blending with markers

1 Lay down a light base colour. I used B02 for this example. You may want to leave some areas white to create highlights.

2 Use a mid-tone (FB2 was used here) to add in colour with the feathering method above.

3 Colour back over with the first pen to blend the colours, repeating as necessary until you achieve a smooth gradient.

4 Go back over the darkest areas with a dark tone (I used B28 for this example) and blend again with the midtone (FB2), before blending over the whole shape with the first colour (B02) for a smooth result.

Effects with inks

When dripped directly onto the paper, the Various Ink (Copic markers refills) can create many new effects, shown below. The 0 ink is not so much a 'blender' as it is a colour pusher – when dripped into colour, it pushes it outwards. If you are not using Copic markers, rubbing alcohol also produces the same effects.

Small sprinkles of rubbing alcohol were added on top of dripped Various Inks.

Large drops were created by agitating the surface with a cotton bud (cotton swab) on top of dripped inks.

Here the 0 blender marker has been placed on top of layered marker.

Alcohol was dripped on top of splotches made with a marker, then the alcohol was blended into the coloured surface using a cotton bud (cotton swab).

Ink was dripped on to a cotton pad, which was then dabbed directly onto the paper.

The tip of a 0 marker was coloured with a darker colour ,then drawn back and forth across the paper, starting from the top and working down. As the darker colour ran out, a smooth blend appeared.

Colouring skin with markers

Almost every figure you draw will have at least some skin showing, so it makes sense to familiarise yourself with how to colour skin effectively. The short step-by-step here will take you through the process. Once you have completed it using these markers, why not practise some more, using the examples on the opposite page for darker or paler skin types?

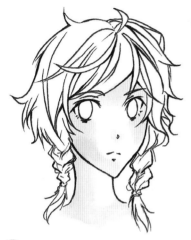

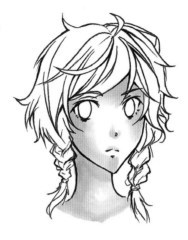

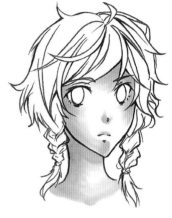

1 Using E000 start to add shading to the areas in shadow. Highlights are created by leaving some areas as clean white paper, so do not just colour the whole face solidly.

2 Using E00, darken the shading leaving much of the E000 showing from underneath.

3 Add E01, making sure to pick out a few hard edges for your shadows.

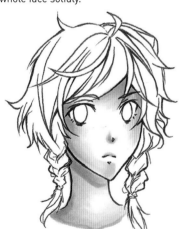

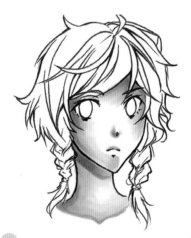

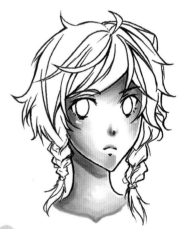

4 Use R02 to further emphasise the shadows.

5 Add BV31 to the darkest parts to add definition.

6 Using white acrylic paint and a fine brush, add the fine highlights as shown to finish.

Skin tone variations

Different skintones require different coloured markers. Using the instructions on the opposite page, try these combinations of colours to build up the different skin tones of the figures shown beneath.

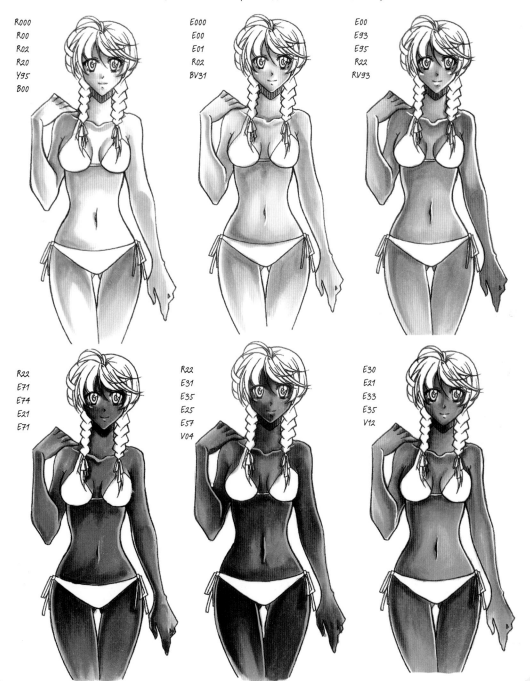

R000
R00
R02
R20
Y95
B00

E000
E00
E01
R02
BV31

E00
E93
E95
R22
RV93

R22
E71
E74
E21
E71

R22
E31
E35
E25
E57
V04

E30
E21
E33
E35
V12

Colouring hair with markers

Hair in manga art varies from naturalistic tones to bright, unnatural colours. The step-by-step tutorial below will walk you through the underlying principles of shading down from the highlights to get depth and vibrancy, whatever colour hair you choose for your figure.

1 Colour the skin first so that any mistakes can be covered by the hair.

2 Leaving the brightest highlights as clean paper, use your lightest tone (in this example, Y08) to create the colour of the highlights.

3 Using your midtone colour (E35 here), colour in the majority of the hair, leaving a few strands of the highlight and light tone showing.

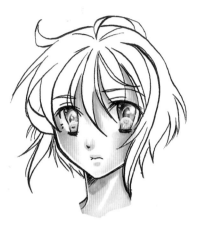

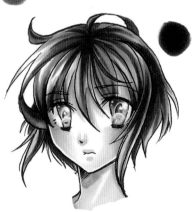

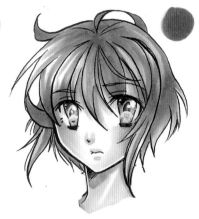

4 Add the first shadow layer with your dark tone (E39), blending it in with more of the midtone colour.

5 Add in your very darkest tones (E29 here) for the deepest shadows, and colour with BV31 where the hair folds.

6 Reinstate glossy highlights using white acrylic paint and a small brush.

Hair colour variations

The swatches here show the highlight, midtone and shades used with the
techniques opposite so you can create any colour of hair you like.

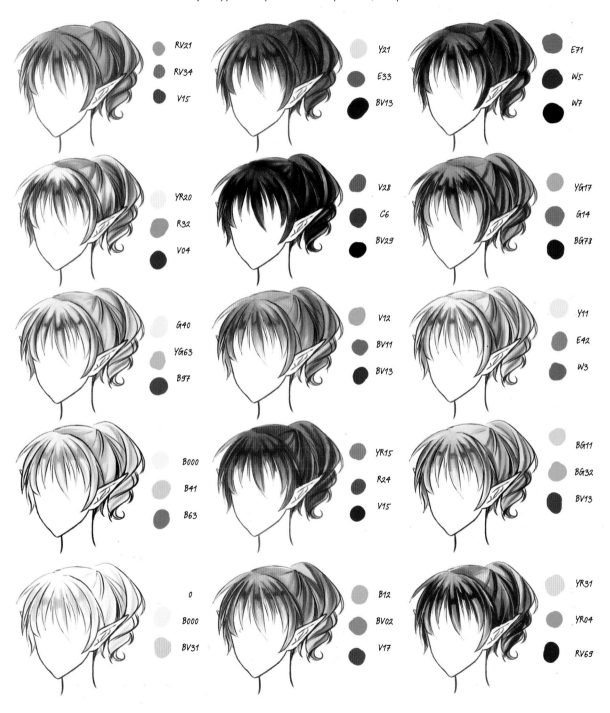

RV21
RV34
V15

Y21
E33
BV13

E71
W5
W7

YR20
R32
V04

V28
C6
BV29

YG17
G14
BG78

G40
YG63
B97

V12
BV11
BV13

Y11
E42
W3

B000
B41
B63

YR15
R24
V15

BG11
BG32
BV13

0
B000
BV31

B12
BV02
V17

YR31
YR04
RV69

Colouring eyes with markers

As explained on page 40, the eyes are really important to giving your figures character. This applies as much to the colouring as the drawing. These pages show how to colour manga style eyes in detail.

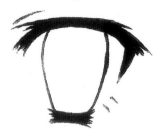

1 Draw the outline using marker-safe ink.

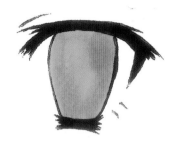

2 Colour the base with your first colour (B02, in this example).

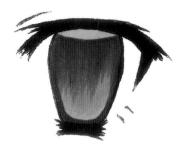

3 Add a gradient with your second colour (B24), then blend downwards using the blender (0). Leave a hard edge around the bottom of the eye.

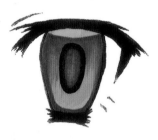

4 Ink the iris and add your third colour (B69) in the centre as the pupil. Blend it into your second colour (B24).

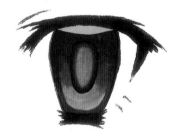

5 Use the third colour (B69) to add a darker gradient from the top, then again blend into the second colour (B24).

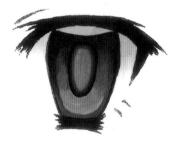

6 Add shadow to the white area for the eye using the fourth (BV31) and fifth (C2) colours.

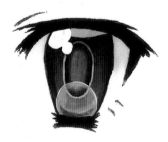

7 Add highlights using blue and white acrylic paint and a fine brush.

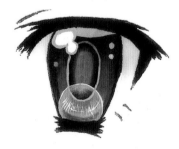

8 Develop the white highlights and add pink and yellow dots with more paint, for reflection effects. Enhance the largest reflection with an internal border of your first colour (B02).

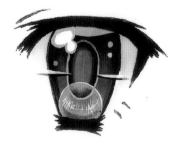

9 You can create a horizon line across the midline of the iris using white paint for a highlight and the sixth (B60) and seventh (C4) colours below it for shading.

Eye colour variations

Just like skin tones, eyes can be coloured very differently. Using the instructions on the opposite page to guide you, try these combinations of colours, along with the blender (0) for varied and exciting results.

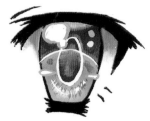

B02, G02, RV02,
RV06, BV31, N3

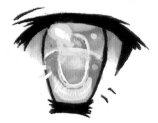

Y02, Y15, TR04, YG03,
G14, G16, BV31, N3

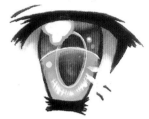

B000, FBG2, B02,
V04, B63, BV31, N3

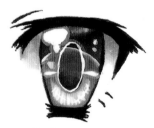

Y15, Y04, Y68, V15,
V17, BV31, N3

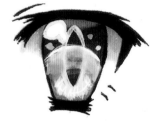

Y08, E35, E39,
E29, BV31, N3

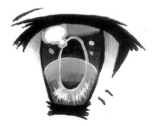

B32, BV11, C5, C8,
N9, BV31, N3

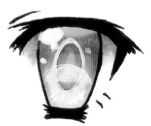

Y02, YG03, YG06,
G07, G85, BV31, N3

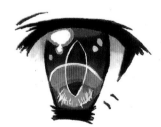

FRV1, R46, R59,
RV69, BV31, N3

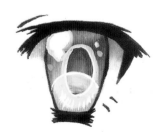

Y02, Y17, YR18,
Y28, BV31, N3

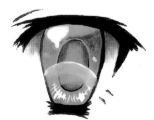

BG01, BG34, G02,
BG05, BG49, BV31, N3

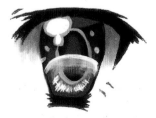

YR04, R17, R46,
R59, RV99, BV31, N3

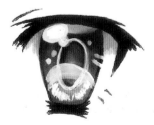

E70, E71, W5,
W7, BV31, N3

Colouring a figure with markers

This step-by-step exercise will show you how to build up a figure using everything you have learned so far in the book, as well as how to use markers to produce a fully complete piece of manga artwork.

When colouring with markers, I work section by section, working quickly so that the colours blend while the ink is still wet.

Note that the colours of marker pens will change slightly when dry. Always start colouring with the lightest tones as mistakes can easily be covered by darker colours.

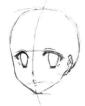

1 Draw the face as described on page 18.

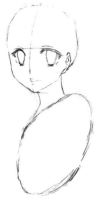

2 Add the ribcage, making it the same height as that of the neck and head combined.

3 Extend the torso down and add shoulders, breasts and hips.

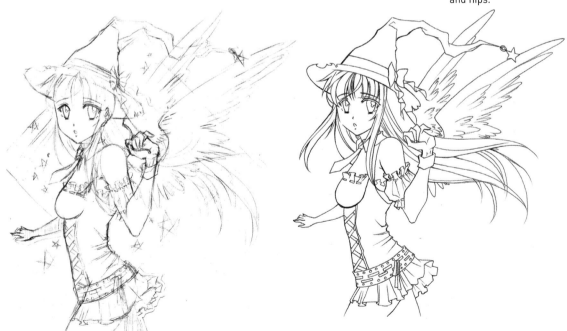

4 Add the legs and arms in to finish the figure, then add clothing and hair to the sketch.

5 Ink the drawing using a fineliner.

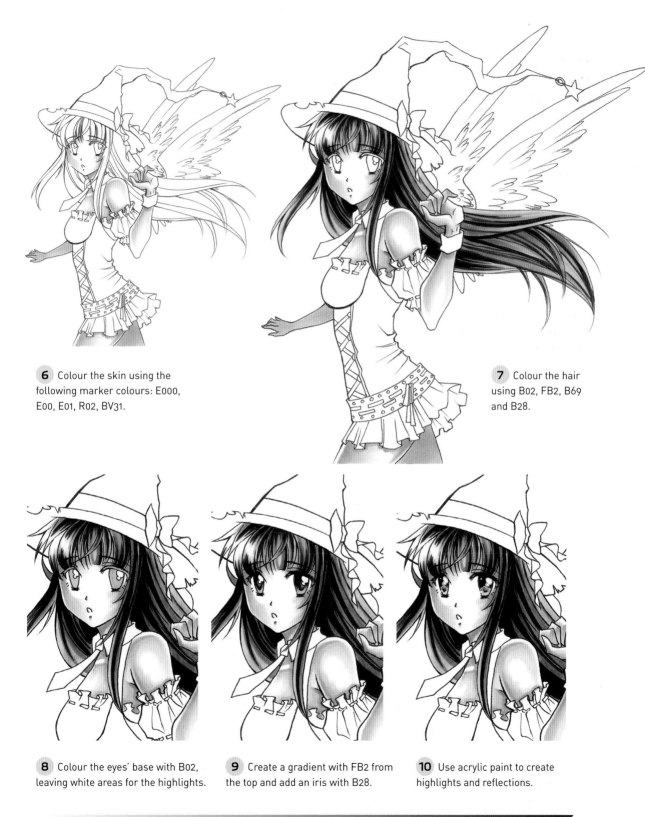

6 Colour the skin using the following marker colours: E000, E00, E01, R02, BV31.

7 Colour the hair using B02, FB2, B69 and B28.

8 Colour the eyes' base with B02, leaving white areas for the highlights.

9 Create a gradient with FB2 from the top and add an iris with B28.

10 Use acrylic paint to create highlights and reflections.

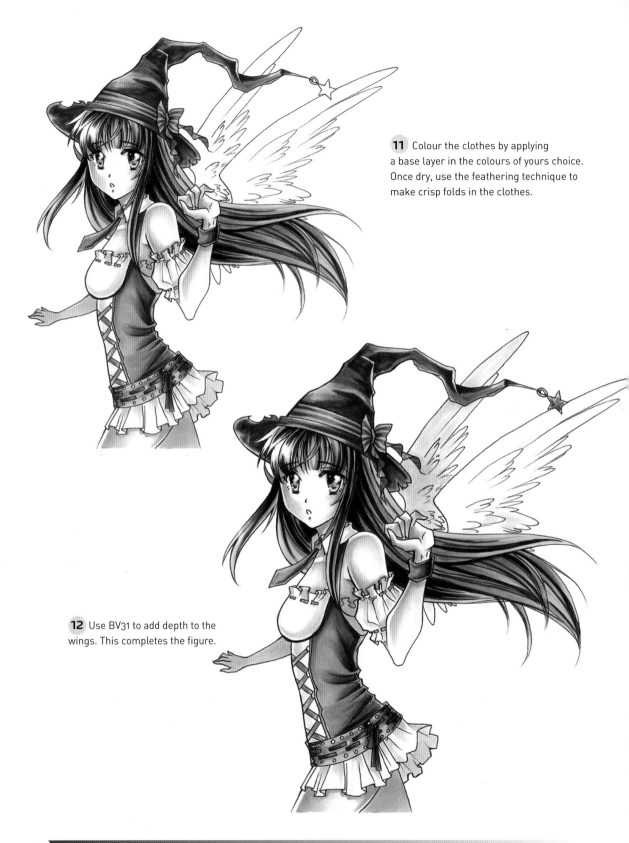

11 Colour the clothes by applying a base layer in the colours of yours choice. Once dry, use the feathering technique to make crisp folds in the clothes.

12 Use BV31 to add depth to the wings. This completes the figure.

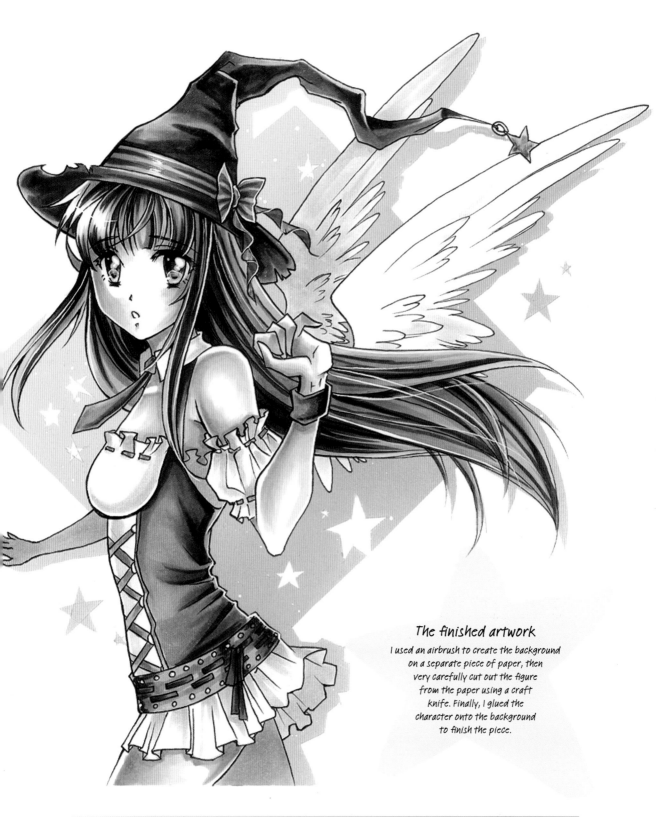

The finished artwork

I used an airbrush to create the background on a separate piece of paper, then very carefully cut out the figure from the paper using a craft knife. Finally, I glued the character onto the background to finish the piece.

Watercolours

Watercolour paint has a transparent quality, which means that you can see through it to the layer beneath. This effect allows you to use many techniques such as glazing (see page 140) to build up the colours slowly, which creates a more delicate effect than most other media.

Watercolour also gives you the ability to vary the depth of colour by varying the amount of water that you add – adding little water results in bright, saturated colours, while very muted light colours can be created simply by diluting the mix with more clean water. In addition, using watercolour allows you to quickly cover large areas with paint as well as create a flow of colour across the page.

Some of the drawbacks of working in watercolour is that it is so light and delicate that getting a scanned version to look like the original is very hard. It takes significantly more editing to get the colours back to the state you want them to be in, and even after a lot of editing it will never be quite the same as the original.

Watercolour, as the name suggests, involves wet paint, so it is important that you use waterproof ink for the inking stage, or you risk the colours bleeding and mixing. You can, of course, paint without inking. I personally use a mechanical pencil for my lines when I intend to paint in watercolour, but many professional artists ink their watercolours as well.

I enjoy painting with watercolour because it is much faster than alternative media. The speed of painting with watercolour is very refreshing, and the ability to place water and pigment in only the areas you want without much fuss allows you to create softer artworks and a more relaxed pastel effect for your artwork.

Opposite:
Because of their soft qualities, watercolours make an excellent basis for backgrounds and locations to set your more striking figures against. See pages 172–175 for more ideas on background.

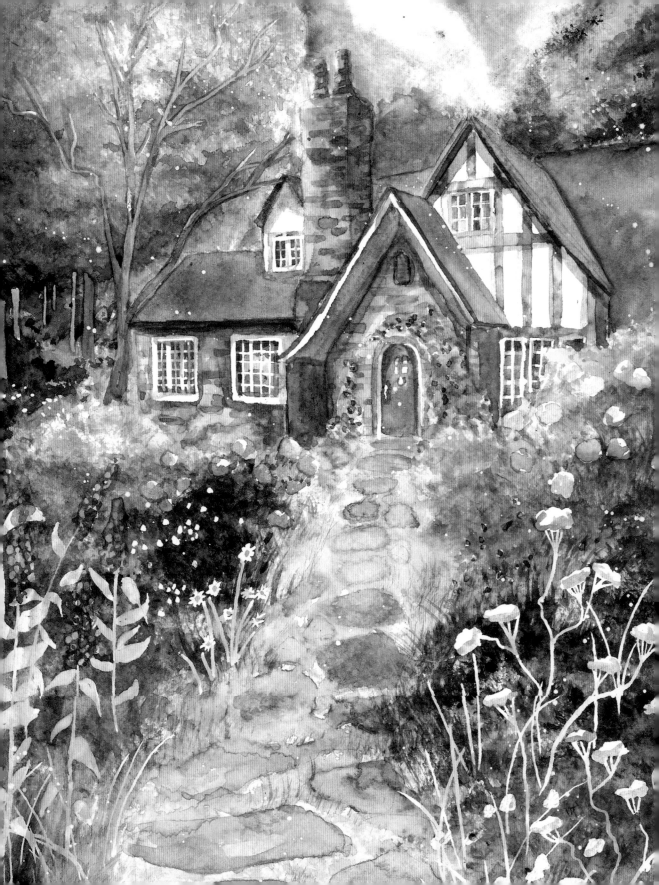

Types of watercolour

Watercolour paints

Watercolour paints are available as pans or tubes. Tubes have wet paint in them, while the pans are dry blocks of pigment that need to be wetted to prepare. On the other hand, they are easy to store and transport. You can get the best of both worlds by squeezing tubes of paint into empty pans to allow you to pick your paint brand and colours for easy movement.

Watercolour paints are available in ranges aimed at students and professional artists. The difference between students' and artists' watercolours is that the artists' ranges have more pigment in the paints. They are higher quality and usually more lightfast (meaning that the colour will stay over time) due to the increased pigment. Students' quality paints are fine to start with while you experiment, but the colour depth and increased pigment of artists' colours make them very nice to paint with once you have become more used to painting.

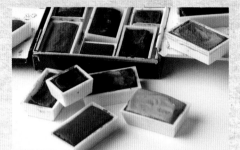

Watercolours in pans

Concentrated watercolours

Bought in dropper bottles, concentrated watercolour does not blend like regular watercolour. Instead, the pigment works more like dye and sinks straight down in the paper. To paint with this medium it is best to start with a lot of water and slowly build up colour in layers. The colours are very bright so it is a great way to add saturation to an image. The paper types you use for these colours are the same as for regular watercolours.

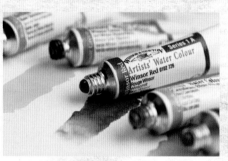

Tubes of watercolour paint

Inks

While not watercolour paint, inks can be used with many of the techniques described in this section. Like concentrated watercolours, they are bought in dropper bottles.

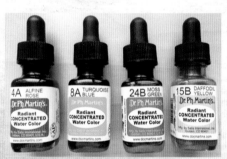

Concentrated watercolours

Colour palette

The following list is my personal palette of colours, which will provide a starting point when you go out to buy your own.

1 Cadmium yellow
2 Yellow ochre
3 Cadmium orange
4 Raw sienna
5 Burnt umber
6 Cadmium red
7 Alizarin crimson
8 Dioxazine violet
9 Cherry red
10 Jaune brillant no. 2
11 Yellow-green
12 Chrome oxide green
13 Emerald green
14 Cerulean blue
15 Payne's gray
16 Lamp black
17 French ultramarine
18 Prussian blue

1 2 3 4 5 6 7 8 9 10 11 12 13 14 15 16 17 18

Inks

Brushes for watercolour

Sable brushes are usually the best for watercolour painting, but they can be very expensive. If you are just starting out with watercolour, I recommend using synthetic fibre brushes, which are cheaper.

Once you have had some time to practise with watercolour, you might want to invest in some nicer sable brushes. My favourites, pictured on the right, are made of either red sable or squirrel hair.

Watercolour brushes come in a variety of styles and sizes. Try out a few types and choose whatever feels right to you for your own work. The two main types are flat and round brushes.

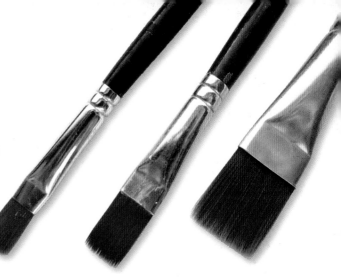

Flat brushes

Flat brushes

These brushes have a crimped ferrule (the metal part which holds the bristles) which creates a flat brush shape. They are usually used in manga art to create solid background washes.

Round brushes

These have a round ferrule, and come to a fine point. Round brushes are your 'go-to choice' for more detailed work.

Round brushes

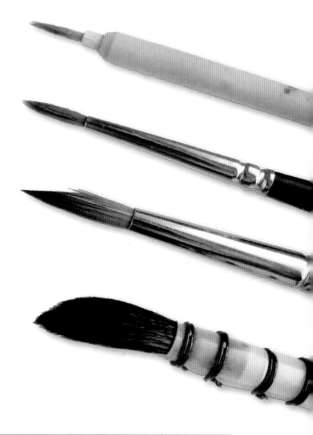

Papers for watercolour

Watercolour papers are available in different weights and surface textures. Experiment with them all to get a feel for what you are most comfortable using. My favourite brands are Canson Montval and Fabriano. Both are fairly cheap but provide nice results. Arches manufacture another brand of high quality paper, but it is expensive.

A selection of watercolour papers

Paper surfaces

Cold-pressed paper has a subtle texture, or 'tooth'. It is easy to find and available in lots of different sizes. I recommend starting with this type because the tooth allows for the artist to control the water and paint more easily because it gets in the grooves of the paper. In order to keep the tooth, avoid erasing on this surface. Instead, make your initial sketch on a separate sheet and transfer only the final clean lines to the watercolour paper – consider this similar to the inking step. The surface is also called Not (short for 'not hot-pressed').

Hot-pressed paper, also called HP paper, is smooth and flat. Some artists prefer this lack of texture. Rough surface paper has a heavy tooth, and is less useful for manga. Nevertheless, I encourage you to play with all types of surface to see which one is easier for you to work with.

Paper weights

Paper comes rated with its weight in grams per square metre (gsm) or pounds per ream (lb). Anything that is 300gsm (140lb) or lighter, (i.e. a smaller number), should be stretched before painting to avoid the paper buckling when you apply wet paint to it.

Other materials

In addition to the paints, brushes and paper surface, you will also need the following for watercolour painting:

Two water containers Use the first to rinse out dirty brushes, and keep the second one clean to use for preparing colours and for use in your painting.

Kitchen paper Use this to clean and dry your brushes between colours, and also for the lifting out technique on page 140.

Salt, rubbing alcohol and plastic food wrap These optional extras allow you to create special effects (see page 141).

Stretching watercolour paper

Lightweight watercolour paper needs stretching to avoid it buckling and cockling when you apply wet paint to it. Heavier paper is less likely to buckle but many artists still stretch it just in case.

1 Transfer your sketch to the paper first, then submerge the paper in clean water. You can do this in the bathtub or sink if you do not have a pan available.

2 Let the paper sit in the water for a minute or so.

3 Pull out the paper and blot off the excess water using a piece of kitchen paper. Do not rub the kitchen paper over the surface as this will ruin your lines. Instead, gently dab the watercolour surface with the kitchen paper, or place it flat on a flat towel and gently press down on top with another piece of kitchen paper.

4 Tape down or staple the edges of the watercolour paper to a piece of thick, solid board and allow to dry completely. This usually takes about an hour, but thicker paper may need to dry overnight.

Watercolour techniques

Watercolour is a very versatile medium that allows a lot of exciting effects. The techniques shown here are some of the most useful. Practise each technique on some spare paper beforehand to get yourself used to how your brushes, paints and papers interact.

The figure on page 142 shows examples of how – and where – you can use these techniques on your figures.

Wet-on-dry (1)

This refers to putting wet paint on dry paper with a brush. This gives you control over the shapes you paint, and creates hard edges as shown. You can drop more colour into wet paint to create shading techniques.

Wet-on-wet (2)

Putting wet paint onto wet paper, or into areas of wet paints, will make the colours run and blend. You can put down water only on certain areas then drop in paint. The result is looser and you have less control than working wet-on-dry.

Glazing (3)

This is the main technique used for shading with manga. Glazing is painting a wet layer of paint over a completely dry layer. Because watercolour is translucent, the colour beneath affects the colour on the top, as shown in the example. Usually the first layer is worked wet-in-wet and glazing layers are wet-on-dry to avoid the risk of the wet colour mixing with the underlying layer.

Lifting out (4)

After watercolour has been put on the surface, it can be picked up or 'lifted out' to soften the result. You do this by lightly touching the area with kitchen paper while the paint is still wet. The absorbent paper will soak up some of the wet paint from the area and result in a soft, lighter-coloured area, as shown.

This can also be used to clean the paper if you make a mistake and put paint where you don't want it. If the mistake has dried, you can rewet the area with clean water and lift out the colour.

Salt (5)

Dropping table salt onto wet paint and allowing it to dry will create a star-like pattern which is great for backgrounds and adding texture. You can brush away the salt from the surface once the paint has dried completely.

Plastic food wrap (6)

Placing crumpled plastic food wrap onto wet paint and allowing it to dry will result in a pattern a little like stained glass when the food wrap is removed. Like the salt technique above, this is great for adding texture and interest to your paintings.

Masking fluid (7)

Masking fluid, also known as liquid frisket or liquid resist, can be applied to the paper and painted over once dry. It protects the surface underneath and, when later removed by gently rubbing it away with a finger, will reveal the clean paper surface beneath.

Masking fluid will quickly clog up and damage your brushes, so use either an old brush or a tool like a ruling pen, colour shaper or dip pen to apply it. Wash the tool well after use.

Rubbing alcohol (8)

When dripped onto wet paint, rubbing alcohol (also called isopropyl alcohol) pushes away the water and sucks in the pigment, creating bubble-like shapes.

TOP TIP !

Avoid using white paint with watercolours as it can make the paint muddy. Instead, add water if you want a light colour and use the white of the paper to create highlights.

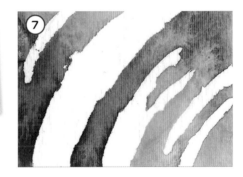

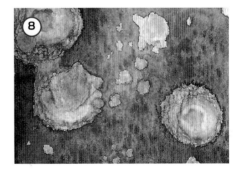

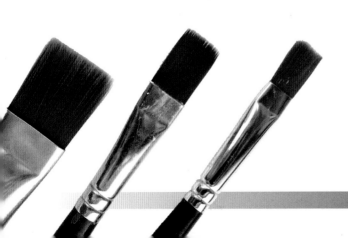

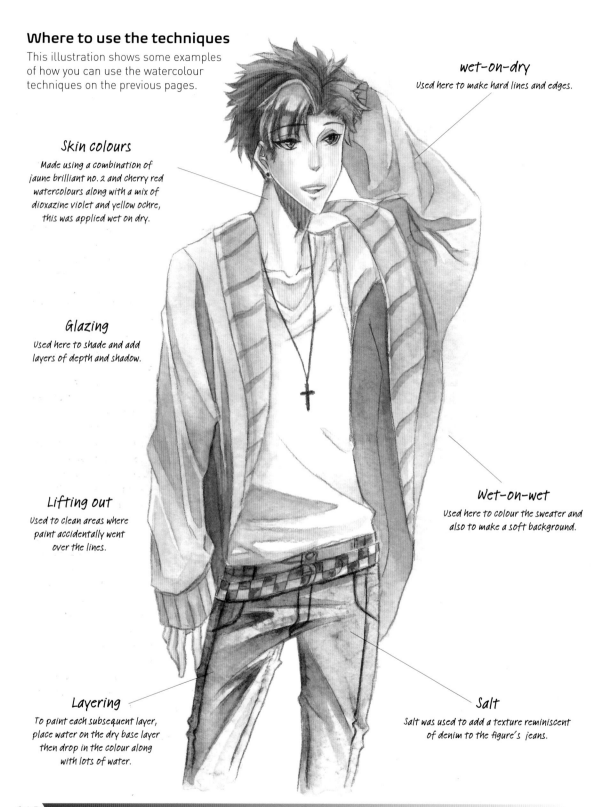

Where to use the techniques

This illustration shows some examples of how you can use the watercolour techniques on the previous pages.

wet-on-dry
Used here to make hard lines and edges.

Skin colours
Made using a combination of jaune brilliant no. 2 and cherry red watercolours along with a mix of dioxazine violet and yellow ochre, this was applied wet on dry.

Glazing
Used here to shade and add layers of depth and shadow.

Lifting out
Used to clean areas where paint accidentally went over the lines.

Wet-on-wet
Used here to colour the sweater and also to make a soft background.

Layering
To paint each subsequent layer, place water on the dry base layer then drop in the colour along with lots of water.

Salt
Salt was used to add a texture reminiscent of denim to the figure's jeans.

Colouring a figure with watercolour paint

This short step-by-step painting shows you how some of the techniques on the previous pages can be used. Because it dries quickly, concentrated watercolour combines well with other media. Acrylic paint is used to complement watercolour in this example because it works particularly well for highlights – just be sure that the watercolour is dry before you apply it.

1 Draw your sketch on copy paper, then transfer it to the watercolour paper. Stretch the paper and allow it to dry properly to avoid buckling.

2 Use a size 10 round brush to place water on the leaves in the background. Allow the water to go over the lines and spread out. While the paper is still wet, use very dilute yellow green to add a light base colour that bleeds over the line but not onto the character. Allow this to dry completely before continuing. Repeat this for each different colour area on the picture (the hair, the skin, and the clothes), allowing each area to dry before starting on the next colour so they do not run together. You can use a hairdryer to speed up the drying process but keep it about 25cm (10in) away from the paper to avoid blowing the paint with the water.

3 Use yellow ochre, dioxazine violet and cadmium orange to add shading to the hair through glazing. Again, make sure you let each colour dry before placing more paint. The hair here was done in five layers, allowing each to dry before applying the next.

4 Use emerald green to darken the leaves in the background. Avoid using black to shade as this will make the colour muddy – if you want to make a darker colour add a little of the complementary colour to the mix or use a colour next to it on the colour wheel rather than adding black.

5 Add the base colours to the eyes – emerald green in this instance – and continue strengthening your shadows across the painting. Each section will take about three layers of glazing. Allow the previous layer to dry before continuing.

6 Darken and glaze the clothing using dioxazine violet and Payne's gray mixed with the base colour of the clothing. If you are unsure where to add shadows, start your shading with light tones and gradually darken them with more layers.

7 Paint the eyes using more concentrated paint (i.e. adding less water to the paint when preparing the mix) to make the colours stronger than the rest of the painting. This adds contrast and will draw the viewer's eye.

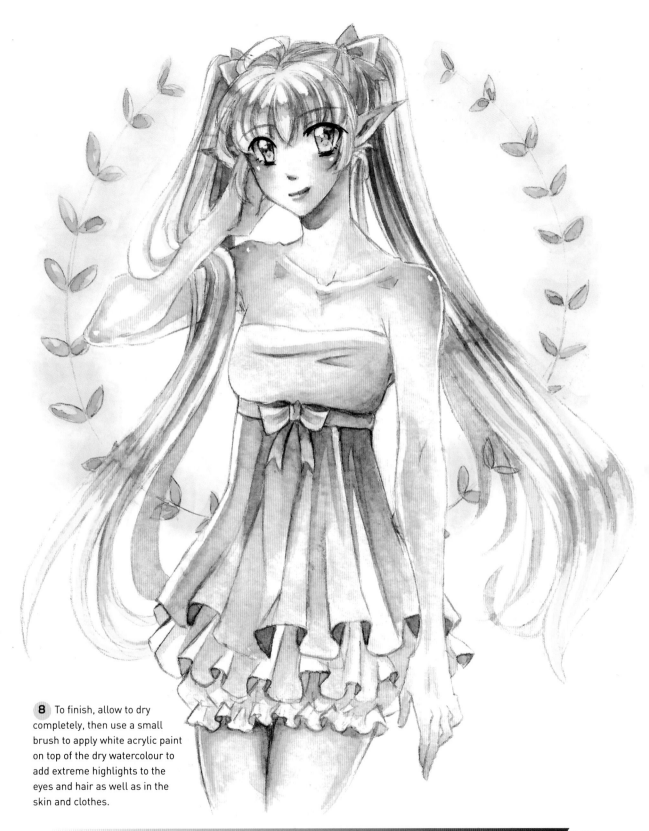

8 To finish, allow to dry completely, then use a small brush to apply white acrylic paint on top of the dry watercolour to add extreme highlights to the eyes and hair as well as in the skin and clothes.

Colouring a figure with concentrated watercolour

Because it dries quickly, concentrated watercolour combines well with other media. This step-by-step walkthrough will show you just a few ways of combining watercolours with other media. You can use marker or coloured pencil as either a base or to shade the base of the watercolour.

1 Sketch your image and transfer it to watercolour paper. Lay the first few layers of paint using a mixture of orange, brown, pink, and tangerine with lots of water to slowly build up the colours. Try to create hard shadows, as soft shadows will not blend properly.

2 Colour the base of the hair with a gradient of pink and yellow concentrated watercolours, using a matching colour to ink to ensure a cohesive finish (pink in this example). Leave the highlight white in her hair as this will make it seem more reflective.

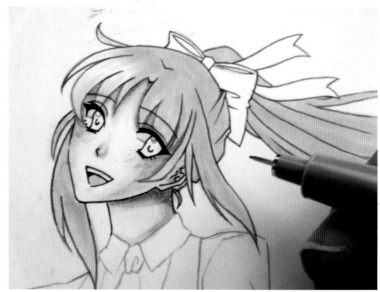

3 Colour in the eyes using a base of pink concentrated watercolour on the bottom and light blue paint in a second layer on the top half. Then I use acrylic paint, white, blue, yellow and pink, to create stronger highlights. At this point I also shade the whites of the eyes with a light grey paint.

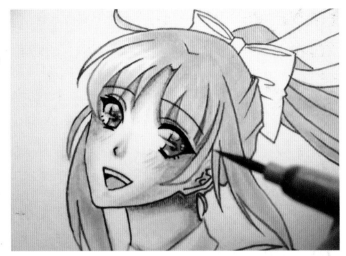

4 Mix together the same pink from the hairs base with light brown and purple to create depth, then use this to add the basic shading of hair strands in. Use this colour to paint the yellow sections as well to create the impression that the hair has a gradient colour. Use the pure undiluted version of the yellow on the tips to make it pop.

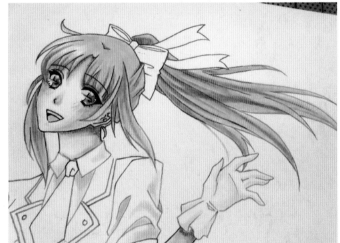

5 Mix blue with Payne's gray and black and dilute it heavily. Use this to add in the base of the dark blue parts of her outfit. Leave the edges here white – they will be a bright light blue later, and leaving them clean will allow you to layer them properly, keeping the light blue separate from the dark blue.

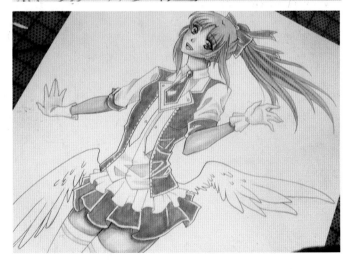

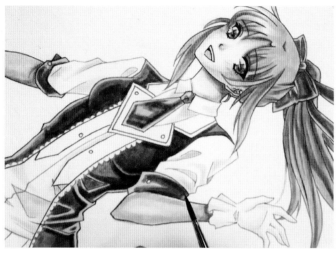

6 Add a mixture of dark blue and black in diluted layers to build up darker colour on the blue outfit gradually. Once this layer is dry use undiluted light blue to get the full saturation in the outfit highlights. Use very diluted purple to colour the shadows of the white shirt.

7 Using light grey and brown, create the plaid pattern. It is important that the lines rotate in the skirt – it is pleated, not flat, so the pattern should follow the folds. Avoid having the lines parallel when painting. In addition to the crossing lines, darken the spots where they overlap to add depth to the pattern.

8 Use undiluted yellow to make the accents pop. This character was designed using a primary triadic colour scheme.

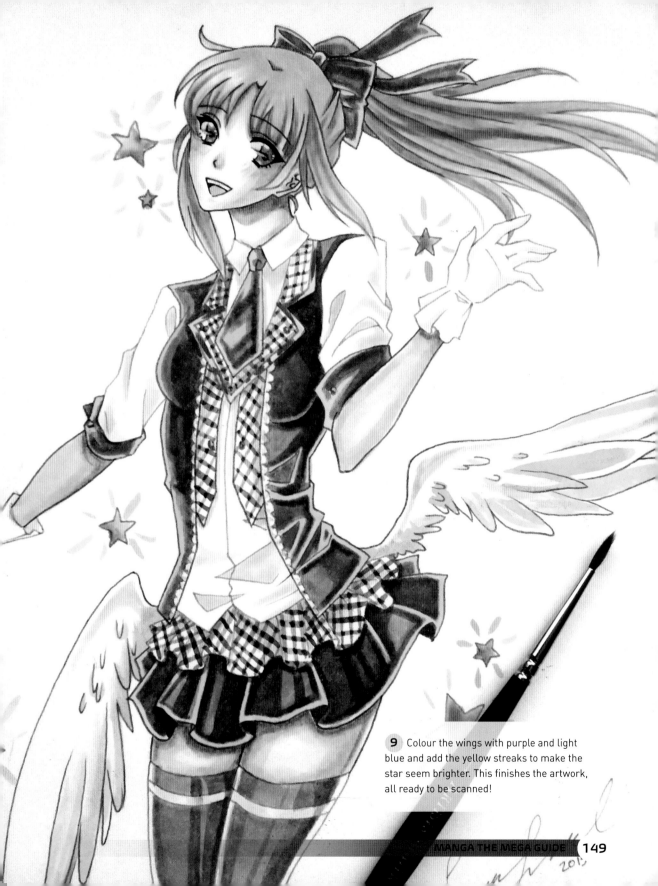

9 Colour the wings with purple and light blue and add the yellow streaks to make the star seem brighter. This finishes the artwork, all ready to be scanned!

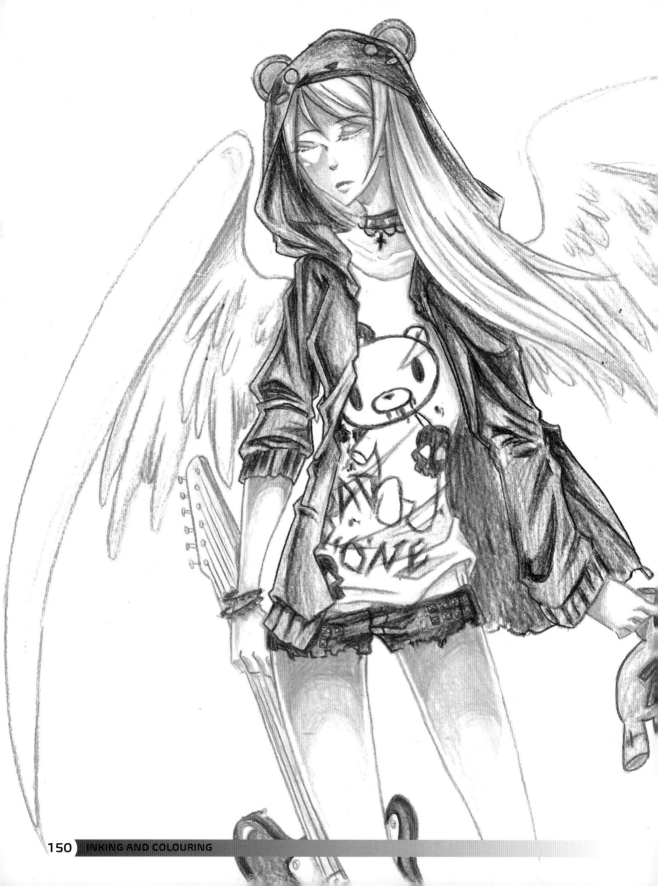

Coloured pencils

If you can use a pencil, you can use a coloured pencil, and this familiarity makes them great to start with if you are nervous of using paints and brushes. They are a versatile medium with their own unique appeal and advantages, so it is well worth trying them out for new effects.

Coloured pencils are available in a large range of colours and offer a great deal of control, which allows for precise colour placement and blending. Depth of tone can be achieved through greater pressure or gradual layering, so they reward a patient approach as well as offering immediacy and consistency.

Types of coloured pencil

Coloured pencils are available in many types. For preference I use Prismacolor brand pencils for their ease of blending and shading, but there are many other brands that produce great coloured pencils, such as Faber-Castell's Polychromos pencils or Lyra's Rembrandt range. The main thing to look for is a broad range of colours,

It is important to keep the tips very sharp when colouring. In particular, sharpen your pencils often during colouring when using heavy pressure to create a darker colour, as this will quickly wear away the point.

Papers for coloured pencil

Any thick smooth paper will work for coloured pencil work. I personally use marker paper, manga manuscript paper or smooth illustration Bristol board. If you prefer a tooth to your paper, good thick drawing paper is also good.

 (1)

 (2)

 (3)

Coloured pencil techniques

 (4)

Hatching (1)
Hatching creates tone and shading by placing sets of lines next to one another to create value changes. Making the lines close together gives darker tones, while spacing them out gives a lighter-toned effect. Hatching is particularly useful for backgrounds and clothing textures.

Cross-hatching (2)
Cross-hatching involves working a second layer of hatching in the opposite direction over the top of the first. This creates a darker, closer effect.

Blending in circles (3)
Using small circular motions with gentle pressure can create a larger area of smooth gradient. It is a good way to build up gradients without creating lines.

Straight line shading (4)
You can either work layers lightly over one another for deeper tones, or simply apply more pressure to the pencil. Both approaches work particularly well for suggesting a curve to an area, which makes this technique useful for hair and shadows.

Colouring a figure with pencils

This step-by-step project will show you just how vibrant a result you can get when using coloured pencils. Paint does not work very well on top of coloured pencils, so it is important to plan your highlights ahead of time when using this colouring medium.

 I chose to use pencil for the outlines to keep the final image light, but you could also ink with actual pens at step 2 if you prefer a stronger, more striking image.

1 Draw out a rough sketch of the character. Your lines do not have to be perfectly clean as this is not the final linework. Use light pencil shading to mark out areas of shadow, such as on the right arm and under the skirt. This will make it easier for you to understand where the shadows fall. Draw the clothes in enough detail that you can see where your shadows and highlights will fall when colouring.

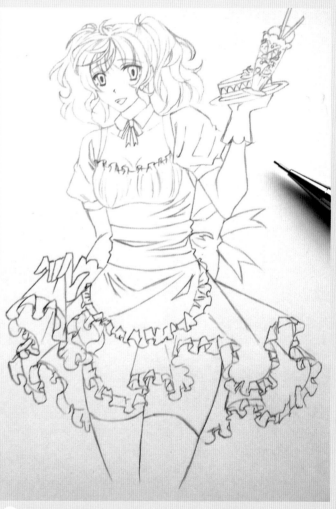

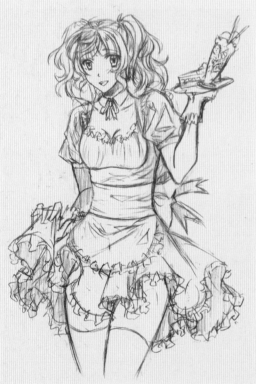

2 Using a lightbox, trace the outlines of the image onto the paper you want to colour upon. Keep these lines light, but make sure they are precise – this part is equivalent to inking the image.

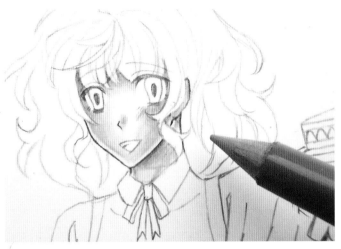

3 Start colouring the skin using a very light peach colour, then add light orange for shading, followed by light pink in the darkest areas. The mix of orange and pink tones in the recesses creates the skin colour depth. Next, add light grey-purple in the darkest areas and go over the lines with a dark red.

4 Colour the eyes with successive layers of bright yellow, light green, mid green and dark green, making sure parts of the previous layers are visible beneath at each stage. To finish the eyes, use a dark green multiliner pen to further define the eyelashes and pupil to create dark levels of contrast.

5 Colour the hair using light yellow, being sure to leave the highlight areas as clean white paper. Concentrate the highlights along the edges of the hair and along the fringe where the light is reflected for a glossy effect.

6 Add basic shadows to the hair using a light orange and dark orange, then change to a dark pink to add the deepest shadows and light purple for the areas of the hair that are further back in the picture. Focus the shadow next to the brightest highlights here for the greatest contrast and a stylised effect.

7 Use a dark red to go over the linework of the hair to really make it 'pop'. This colour will also help to unify the colour scheme.

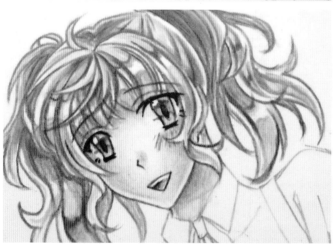

8 Continue using the same colours to blend and adding shadows in the darker areas near the head, and top of the pigtails. Use the pink and red pencils to colour inside the mouth, leaving a line of clean white paper for the row of teeth.

9 Colour in the arms and thighs with the same colours you used in the face (see step 3). Coloured pencils do not blend well over large areas, so avoid this by creating smaller areas of concentrated hard shadow using the purple and dark pink. Check the overall colour balance before continuing.

10 Use a dark red to colour the outlines of the white fabric, then change to a light purple to add in shadows on the apron and the white areas of the outfit, such as the stockings, the gloves and the white dress ruffles.

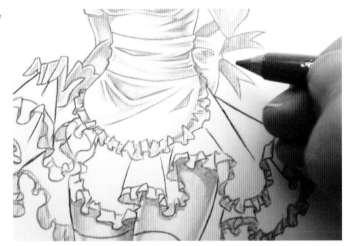

11 Blend light blue into the purple for the darker recesses areas of the apron and white fabric. This creates depth and interest. Always try to shade with more than one colour, rather than simply darker versions of the same colour.

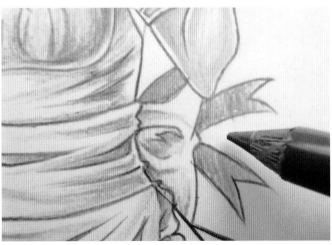

12 Continue over the rest of the figure, working section by section and colouring each part entirely, rather than placing the base colours over the whole image then layering the shadows as a separate stage. Use light pink and a medium purple-pink colour for the surface of the dress. Colour over the pink fabric outlines and details using dark red.

13 Add depth to the image by using a dark blue pencil to colour the outlines of the lower, more distant part of the part of the skirt. Use very light pressure to add a layer of the dark blue to the underside of the skirt. Creating this difference in the shadows gives depth to the image, by giving the impression of three-dimensional space.

14 Use bright colours of your choice to colour in the plate of cake and the parfait. Both are small and detailed, so make sure to leave some areas white and uncoloured in order to suggest highlights in these smaller details.

15 To finish, go over and add depth to the shadows by overlaying more pencil where you see fit. Aim to balance the light and contrast in the image.

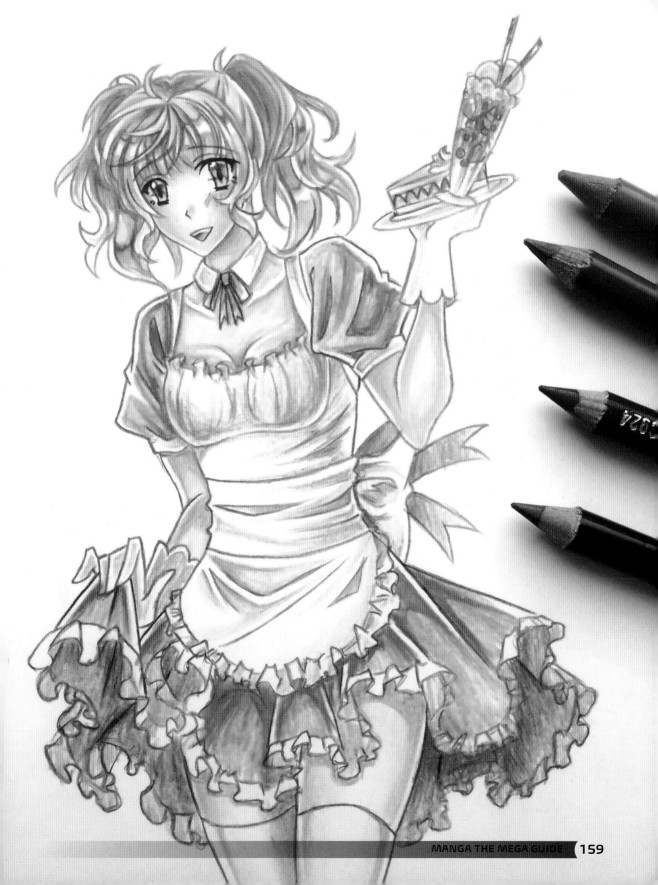

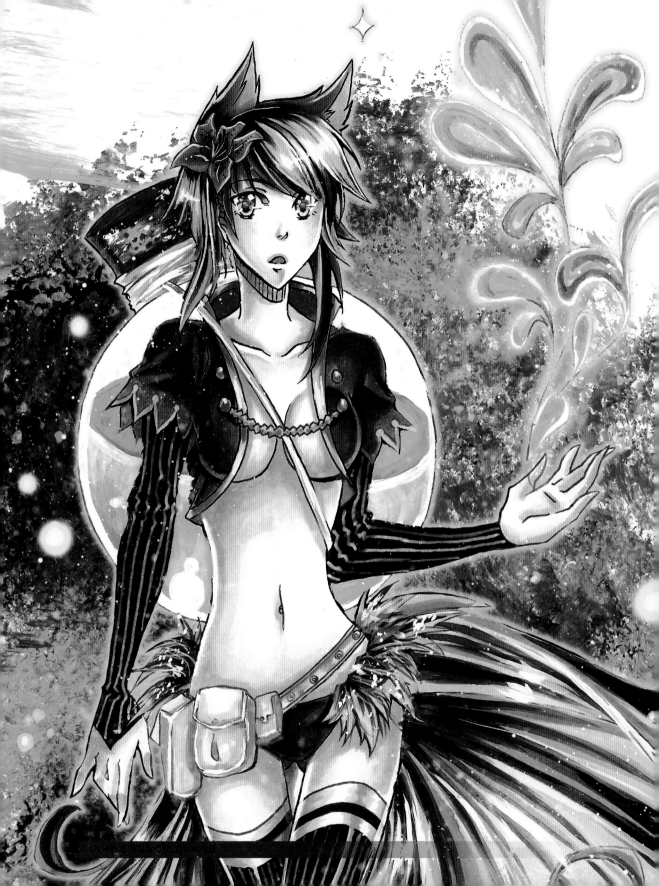

Acrylics

Acrylic paints can be diluted with water and used just like watercolour, though they do not blend so readily as watercolour. For this reason, I tend to use acrylic more for background work, correction and small details rather than for the body of the image. However, acrylics are not just a poor man's version of watercolours. These paints have their own advantages. The real strength of these versatile paints is that they have great coverage, which means they will obscure anything below them. This makes them really useful materials for correcting mistakes and in mixed media artwork. Acrylic lends also itself to hard cel shading (see page 114) so use this to your advantage.

Acrylic paints are available in cheaper students' ranges and more expensive artists' ranges. For correction work, almost any acrylic will work just fine – even cheap craft brands can work in a pinch. Try different brands to find your favourite. It is a personal choice to see which is easier for you to work with and what works with your papers.

While you may use acrylic paints less often than markers and watercolour in your manga artwork, they offer a whole world of different and exciting effects. In this section I will show you how to use these colours for a whole image worked in a style more like fine art work than illustration.

Types of acrylics

Acrylic paint

Bought in tubes or large tubs, acrylic paints are less transparent than watercolour. For this reason, they have better coverage and can be used to add highlights and correct mistakes on works done in other media, such as markers or ink; so if you make a really bad mistake, you can always blend acrylic on top to cover and fix it. Acrylic paints are also available in heavy body ranges, which are thicker than the standard range and worth experimenting with.

Acrylic gouache

Some acrylic paints can dry slightly glossy, so for the flat colours used in manga art, I suggest you use acrylic gouache. Acrylic gouache uses an acrylic-based binder (rather than the gum arabic binder in watercolour and traditional gouache) which means it dries to a matt (non-shiny), water-resistant finish. My favourite brand of gouache is Holbein because it has a wonderful consistency that makes it easy to blend, the tubes last a long time, and will not break the bank.

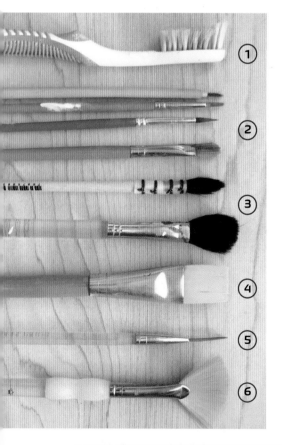

Papers and brushes for acrylics

Brushes

Old toothbrush (1) This is good for spattering paint, a technique which results in tiny dots of white (see page 168 for an example).

Synthetic rounds (2) These small brushes are good for details. Synthetic hair does not hold as much water as natural brushes do but they are stiffer, which gives you more control.

Natural rounds/mop (3) Good for large areas of colour, natural hair brushes hold more paint than synthetics, so you do not need to stop and reload so often.

Large flat (4) A brush that holds a large amount of paint is good for gradients and large areas. The sharp corners give you more control than a mop brush.

Rigger (5) Good for long thin lines, these brushes can hold a surprising amount of paint.

Fan (6) Used for creating texture and leaf-like shapes, these are useful for trees.

Paper

As long as you use any thick, smooth paper for acrylic it will hold the paint without buckling and bending. I personally prefer to use Bristol board for my acrylic work but watercolour paper and cardstock can also be used.

Acrylic painting techniques

Acrylic paint dries slowly and blends very well when applied directly to paper without any water. It does not separate out when water is added, which makes it well-suited for backgrounds and hard cel shading on characters. Here are a few of the main techniques used in manga when painting with acrylic paint.

Layering

This is the most common and useful technique in acrylic. It is opaque when it dries, so you can paint on top of previous layers for clear shapes and outlines without the colour blending.

Layering with diluted acrylic paint

Diluted with water, acrylic can be successfully used with watercolour techniques. Acrylic pigment dyes the paper instantly, so apply the colour in thin layers and slowly add more pigment to avoid mistakes.

Dry brushing

Adding no water and wiping off excess paint will give great textural results as the paint will not flow, but instead come away in dry streaks as shown. This technique is great for thin clouds, tree bark and texturing surfaces.

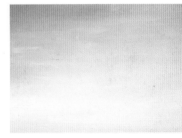

Stippling

Making repeated small dots, or flattening the brush into an oval shape and layering them next to one another gives a great effect for leaves and bushes.

Stippling blending

You can also use stippling to blend together multiple colours if you do it while the previous colour is still wet and paint on top.

Simple gradient

Best for large areas, use a flat brush to paint in an area of your darkest tone with horizontal strokes. While the paint remains wet, repeat with a lighter tone beneath and slightly overlapping the above area. Repeat down to the bottom of the area, finishing with your lightest tone.

Painting foliage with acrylics

The layering technique can be used for trees and shrubs in manga backgrounds. Let each layer dry entirely before proceeding to the next step.

1 Draw out the basic shape you want your foliage to be. Make sure that the shape is not symmetrical. If the shape is thicker on one side, that will help it look more natural.

2 Start painting using a size 2 round brush and a dark blue-green paint. To produce the leaf shapes, flatten the brush on the surface with the tip facing the direction you want the leaves to point. Work over the whole outline to obscure it entirely, leaving pieces jutting out.

3 Add in more depth of colour using a slightly lighter blue-green on top in some areas. Keep in mind the light (see page 112) when placing each layer.

4 Change to a medium green shade and repeat the process. Make sure to leave pockets of blue and dark green from the bottom two layers, and to paint to the edges in some areas, particularly at the top.

5 Proceed to add even more light to the foliage using a light yellow-green colour. Leave a few spots separated from the main blotches to disperse the light.

6 Add in a final layer of light yellow-green mixed with plenty of white as your highlight.

Painting a sky with acrylics

When painting layers you want to blend together, move quickly while the paint is still wet.
To create sharp outlines, wait until the previous layer of paint is dry before painting on top.

1 Using long horizontal strokes, make a simple gradient (see page 163) using dark blue, mid blue, light blue and white acrylic paints. Blend down starting with the dark blue at the top through to pure white at the bottom. Do this while the paint is still wet.

2 Allow the previous layer to dry, then block in the basic shapes of the clouds using the dark blue. Study photographs to better understand the shapes and types of clouds, or copy those shown here.

3 Add pure white highlights to the brightest areas, then blend light blue into some of the areas while the paint is still wet. Allow the remaining highlight areas to remain pure white. Using the dry brush technique (see page 163), add light streaks of white to create a few wispy clouds. Make sure the lines are curves rather than purely straight.

4 Once dry, overlay more pure white on top of the previous layers to create the sharpest edges. Go back and add in the darkest colour of blue in a few areas to strengthen the contrast, which will make the image more realistic.

Colouring a figure with acrylics

Acrylic lends itself well for the techniques in this step-by-step demonstration, as it covers well and is easier to control than watercolours. Acrylic works best in layers so always start with the area furthest back in the image – in this case, the background.

This character is extremely pale to accentuate the contrast in the image. This helps to create a more striking impression of moonlight.

1 Sketch out the image on a piece of cartridge paper, then use a lightbox to trace the image onto the final paper with a mechanical pencil. Make sure you create clean lines as the pencil lines will be akin to inking for this picture. If you do not have a light box, you can also trace by taping the picture to a window or putting a light under a glass table so you can see the image.

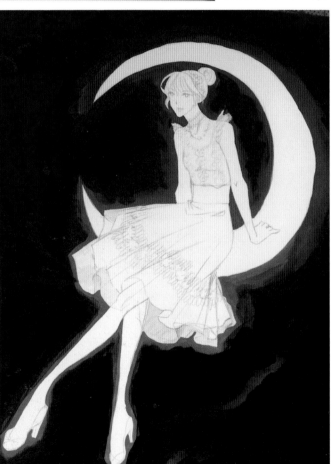

2 Starting with a bright blue, paint the background. Blend in a midnight blue while the paint remains wet, then blend in the darkest colour which is a very dark blue. Leave parts of the light blue showing to create clouds in the sky and leave space around the moon and the girl to create a glowing effect.

3 Slowly build up layers of very diluted colour to shade the skin. Using a combination of light peach mixed with a light blue (more blue than peach) will create a pale tone for the skin.

4 Paint the dress using a very light blue. Allow the layer to dry and then use a slightly darker blue to carefully pick out the folds in the dress. This dress has a layer of sheer white taffeta on top of it, so to show this the shadows cannot be too dark in the bottom layer – keep the shadows light in tone. Acrylic lends itself very well to painting sheer fabric in manga.

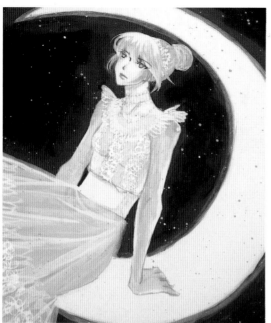

5 Add a little white to the same light blue you used to paint the dress and paint the shadows in the hair with this mix. Leave the upper parts of the hair (those that receive more light) unpainted to show the white colour of her hair. Next, use a light grey to paint the outline of the eyes then paint the eyes with light blue, leaving space at the top to show light reflecting from them. Finally, add a bit of water to white paint. Dip the toothbrush into the dilute paint, hold it near the image and lightly draw your thumb or finger over the bristles. As they spring back into place, they will flick tiny droplets of paint over the image to create little white dots as stars, a technique known as 'spattering'. Use a piece of scrap paper to protect the figure from stray droplets.

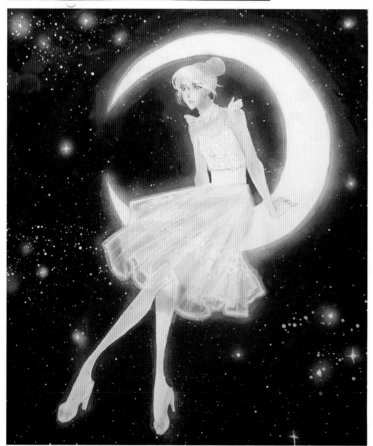

6 Use an airbrush and white paint to outline the character and the moon. Then create little white dots with the airbrush to make some larger, brighter stars. Use a fine brush to add in little dots and crosses in the airbrushed spots after the airbrush layer has dried.

No airbrush?

If you do not have an airbrush, you can create a glowing impression by applying successively lighter and more saturated hues around the character, as shown above. The white area left over seems to glow in contrast.

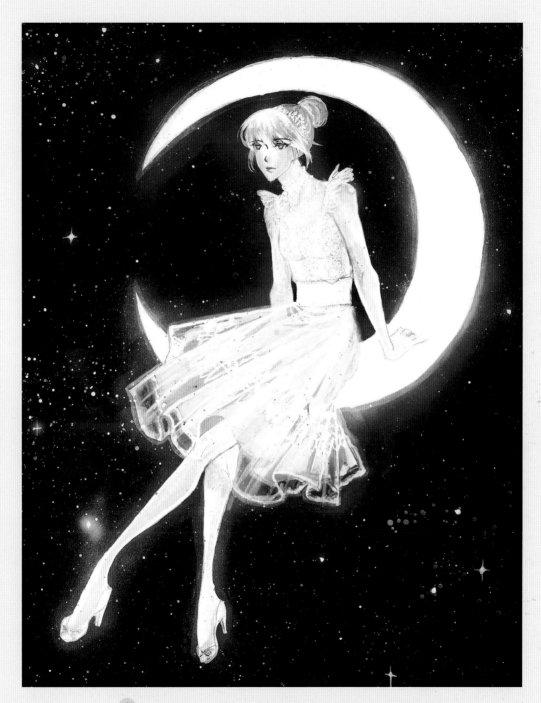

7 Once the work is dry, you can look over the finished artwork and refine any parts you wish, simply by painting over them. Acrylic paint can be used to fix issues in all media thanks to its easy layering capabilities.

Digital tools

Digital tools are a fantastic way to enhance your manga art. Graphic editing programs like Photoshop make all the difference for scanned artwork, allowing you to tweak mistakes and add special effects that would be time-consuming or impossible in physical media.

Scanning artwork

All scanners, no matter how expensive, will alter your colours (some seem to destroy them entirely!) when you scan your originals. However, as long as your scanner can produce colour images at 600dpi (dots per inch), you will be fine. What matters is how you edit the image after you scan it, which is what we will look at here.

I use Adobe Photoshop for most of my digital editing, but there are other less expensive (or free) programs that you can use.

TOP TIP *!*

If part of the picture is discoloured with a grey streak from the process of scanning, you can fix this with the dodge tool. Set it to twenty-five per cent and pick the 'highlights' option. This can be used to clean the streak.

Why 600dpi?

Some home printers will only print to 300dpi, but scanning at a resolution of 600dpi gives you the freedom to resize your artwork and allow for bleed (a printing term for parts of the image that will be trimmed away).

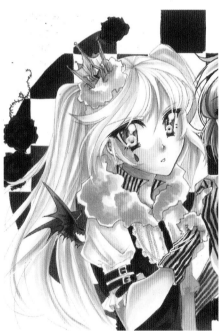

1 Use your scanner to make a basic scan of your artwork. Always scan at a resolution of 300dpi or higher. I always scan at 600dpi and reduce the picture size as needed. Scan in colour for colour images, and greyscale for black and white drawings.

2 Erase any small dots and imperfections on your artwork using your graphic editing program. Small dots on the background like those circled above can simply be painted white with the brush tool (or equivalent). If you have dots on the characters themselves, you can use the dropper tool to match the local colour, or use the clone stamp tool to copy from a spot nearby.

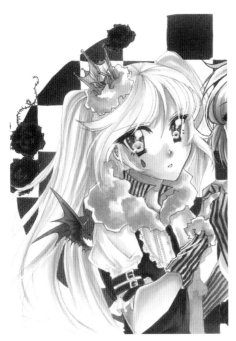

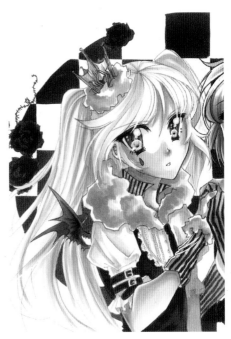

3 To adjust the colours, click on the image tab, then adjustments, then hue/saturation. This will bring up a window with sliders. Hold up the original artwork to your monitor and adjust the sliders until the colours are accurate. In this example, scanning the image had made the skin look washed-out and yellow, so I moved the sliders to strengthen the red and match the original more closely.

4 You can adjust the tone by clicking on the image tab, then adjustments, then levels. Again, this will bring up a window with sliders, which you can adjust to alter the relative lightness or darkness of the colours in the image. This creates contrast. Compare this image with step 3 to see how changing the levels gives the image more impact.

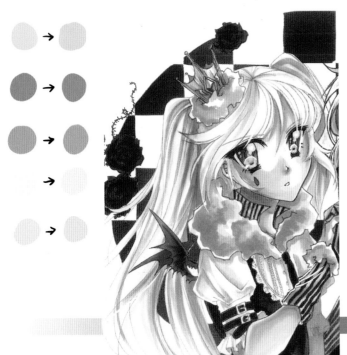

5 At this point, you can begin to replace the individual colours, which is the most important part of this process. Again, click on the image tab, then adjustments, then replace colour. This will bring up a window with a thumbnail image of the picture. Use the dropper tool in the window to pick a spot of the specific colour you want to change, then use the sliders to adjust the colour to match the original more closely. In the example image to the left, you can see the specific colours I have altered.

Other tools

The dodge tool can lighten specific spots and the burn tool can darken them. The sponge tool can be used to saturate or desaturate colours. Use all of these tools sparingly and gradually at twenty-five per cent strength to avoid over-working your image.

Backgrounds

The background examples on these pages have been produced using digital tools, but the principles apply to whatever medium you choose to use. In fact, because background elements are generally less important to your finished image, they are a great way to experiment with different media and techniques. Give them a try, and you will soon be able to place your figures against great backdrops.

Trees

The examples here show common mistakes on the left-hand sides, and improved versions on the right.

Symmetry

Trees are very rarely symmetrical in nature. Make your trees lean to one side and the canopy uneven in shape.

Natural colours

Don't use green and brown. Observe the trees around you, and you will see many subtle hues, including greys, blue-greens and often surprising hues like red or orange.

Placement

A common error is to place the tree sitting on top of a strip of ground, which makes it look unnatural. Instead, run the horizon behind the trunk, and put shadows beneath the tree and under the leaves. This all helps to create a realistic effect and ground the tree.

Clouds

There are many different types of clouds, from fluffy-looking cumulus to wispy cirrostratus. Close observation of the sky will provide lots of inspiration. Try drawing all the different types you see.

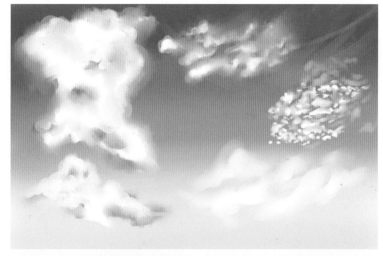

Observe nature

The examples show some different clouds. As with trees, clouds are almost never symmetrical, nor are they just white. Look for many different tones of grey, pink, purple, yellow and even more unusual colours.

Time of day

Try altering the time of day in your backgrounds, as this provides lots of different options for colour and atmosphere. The examples here show the same sky at different times of day. From left to right, morning, sunset and nightfall.

Drawing a tree with digital tools

This exercise is a great chance to try out what you have learned throughout the book and try it out with a program like Photoshop or a free app like Brushes. Of course, the instructions can be adapted to use almost any of the other media in the rest of the book, so give it a go with whatever you prefer.

1 Block in the base colour and shape of your tree using an appropriate brush. Make sure to leave some areas of background clean and white, and add a grey-brown trunk with a less textural brush.

2 Create a new layer and select it. Colour a lighter highlight on top of the basic shape on this new layer.

3 Keeping the selection, add in a darker blue-green for shading.

4 Drop in a mid-toned green, paying attention to the lighting to create a natural gradient between the highlights and shades.

5 Make a new layer and add in white and light blue spots.

6 Create a new layer and make a soft gradient of light blue by setting the layer to 'pin light' or 'overlay' and adjusting the settings.

More examples of trees

Trees don't have to be green – especially in the stylised and fantastical worlds that manga depicts so well. These examples show the colours I have used to evoke different effects. They might offer inspiration for colour schemes, too.

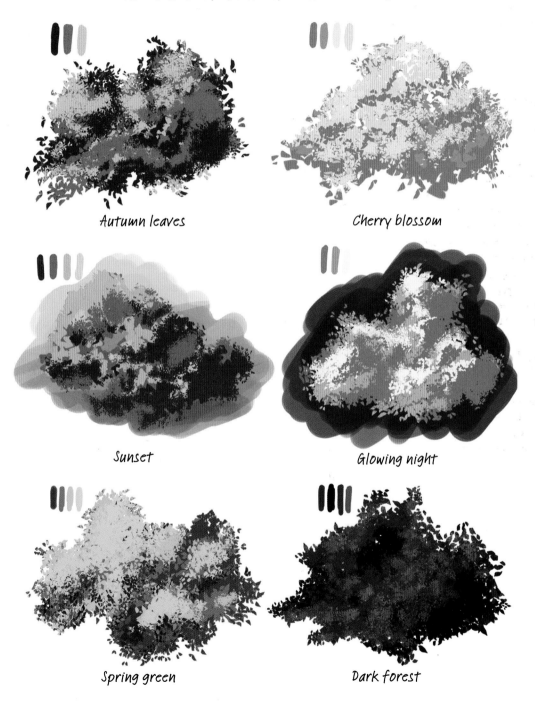

Autumn leaves

Cherry blossom

Sunset

Glowing night

Spring green

Dark forest

Index